IMAGES
of America

MANTUA

To Lisa & Bob —
Enjoy!..
Sue Korroch Shumn

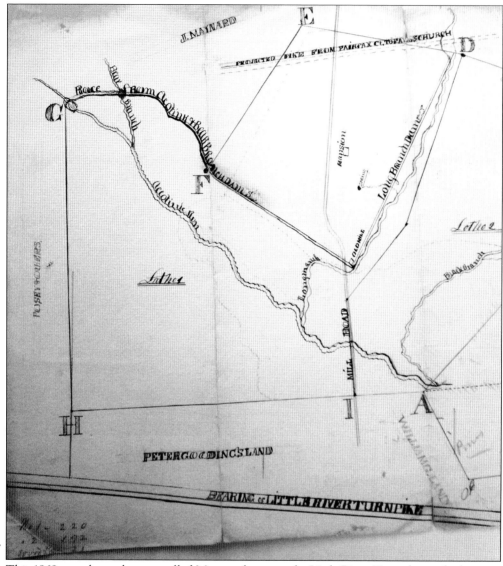

This 1869 map shows the area called Mantua, between the Little River Turnpike, at the bottom, and the "projected pike" from Fairfax Court House to Falls Church. The Accotink Creek and its tributaries are marked, as is the path of the water to the "old mill" on Long Branch. Mill Road, near the bottom, was close to the "mansion"—a house in Mantua. In 1879, John H. Chichester, who lived in that mansion, and other residents proposed that a road be built from the Little River Turnpike through farmland, just east of the old mill. (Fairfax County Circuit Court Historic Records Center.)

ON THE COVER: Mantua was a wooded, wild place before the suburb started developing after World War II. Hunters took their hounds and scoured the areas for game such as birds, wild turkeys, and raccoons. Among the hunters seen here around 1900 are, at far left, John C. Davidson, who married Mary "Minnie" Chichester, the daughter of John Henry and Sarah Chichester, and in the middle of the group holding a wild turkey carcass is James M. Mason, who married Margaret "Madge," another daughter. (Fairfax County Public Library Photographic Archive.)

IMAGES
of America

MANTUA

Sue Kovach Shuman

ARCADIA
PUBLISHING

Published by Arcadia Publishing
Charleston, South Carolina

Printed in the United States of America

Library of Congress Control Number: 2021930020

For all general information, please contact Arcadia Publishing:
Telephone 843-853-2070
Fax 843-853-0044
E-mail sales@arcadiapublishing.com
For customer service and orders:
Toll-Free 1-888-313-2665

Visit us on the Internet at www.arcadiapublishing.com

To my family, my strength

CONTENTS

Acknowledgments 6

Introduction 7

1. A Good Location 9

2. The Chichesters 17

3. Glenbrook Road 45

4. A Suburb Is Born 61

5. A Community Forms 81

6. The "Tank Farm" 95

7. Changes and Connections 111

ACKNOWLEDGMENTS

What do you know about the place you have chosen to call home? Many of us have hometown roots but have been transplanted. This book began in a quest to know more about my chosen area and as part of an internship for a certificate in public history and historic preservation at Northern Virginia Community College. It morphed into this pictorial history; 2020, the year of the pandemic, made the project challenging.

To all who searched scrapbooks, shared memories or suggestions, or steered me to others, thank you. The list includes (but is not comprehensive) Margaret Miller, Kat Robair, Elizabeth Wassell, Martha Close, Cecilia Williams, Donna and Dom Cipicchio, Eda Pickholtz, Martha Lamb, Karen Parker, Margaret Miller, Kathy McLaughlin Roberts, Merlin "Mac" McLaughlin, Sheri Pitigala, Pat Troutman, Judy Wonus, Howard Albers, Tim Eakin Walsh, Kathleen Lockwood Greene, Charla Wilkerson, Molly Gravholt, Andy Pavord, Andrea Loewenwarter, Michael Hill, and Linda McClelland. Cindy Buchanan examined community newsletters for trends and shared photographs. Thanks especially to Mary Wagaman and Douglass Sorrel Mackall III and to Glenbrook Road pioneer Annabelle Royston-Linden. Some people who shared memories are gone: Thelma Kouzes, Ruth Condon, and Chuck Sanders. Their indomitable spirits helped build the community. Builder Colin Sekas provided a souvenir of Mantua's oldest house, demolished in 2020: a piece of timber from the dining room. Thanks to Heather Bollinger and Victoria Townsend of the Fairfax Circuit Court Historic Records Center; Laura Wickstead and especially Chris Barbuschak of the City of Fairfax Regional Library's Virginia Room; Brian Conley at library archives; Fairfax County's GIS and Mapping office; Mary Kimm, publisher of the *Connection Newspapers*; and Gretchen Bulova, for taking the first look at this history. Finally, thanks to Caitrin Cunningham, my editor at Arcadia, for her patience.

Images from the Fairfax County Public Library Photographic Archive are designated FCPLPA; the collections include items from the Henry C. Mackall Papers, 1879–2008, and the Henry H. Douglas Collection. Library of Congress images are designated LOC. I tried to be as accurate as possible about every aspect of this history based on historical records.

I am especially indebted to Marisa Mendoza Bacungan for scanning photographs. Finally, to my always-patient husband, Gene R. Shuman; my son David P. Shuman and daughter-in-law Karla Bacungan Shuman; and my daughter Amanda G. Shuman, PhD, an Asian and Chinese historian who understands how hard it is to make a book. I hope that these glimpses of the past provide a road map to the future and that Mantua preserves some of its mid-century buildings. I hope my grandchildren—Emma, Paul, and Nina—enjoy history as much as their Gram does, or at least enjoy the photographs until they learn to read.

INTRODUCTION

The earliest reference to Mantua land might be this 1845 account by Samuel M. Janney, "a Virginian," in *The Yankees in Fairfax County, Virginia*: "In passing through that unfrequented part of Fairfax which lies between the Little River Turnpike and the middle turnpike at a distance of 15 or 20 miles from the District of Columbia, the traveler finds himself in a wilderness of pines, and journeys for miles without seeing single habitation. In a distance of twelve miles which we traveled through this district, we saw but two or three cabins, and nothing that is entitled to the appellation of a comfortable dwelling for a civilized man. Yet most of this land was formerly cultivated in corn and tobacco and having been exhausted by the mis-directed [*sic*] efforts of man, is now undergoing the process which the bountiful author of nature has provided for the renovation of the soil." There were carpets of periwinkle on pastures—similar to patches in Mantua more than 185 years later. In 1845, Mantua was a working farm with a wood-frame house, perhaps one of the few houses around. It was about three miles from the town of Providence, which is what the Fairfax Court House area was called until 1874.

The land was known to Native Americans, who camped and fished along the banks of the Accotink Creek, which flows through the area and empties into the Potomac River, as long as 9,000 to 10,000 years ago. English settlers established mills along the creek to cut timber and grind flour. Land with water offered an opportunity for prosperity.

Northern Neck land grants from King Charles II of England went to his loyalists in 1649. Some of that land became Fairfax County, named after Thomas Fairfax, sixth baron of Cameron. One of the settlers was English-born William Fitzhugh, who immigrated to Virginia and obtained the 21,996-acre Ravensworth tract in Fairfax County (about half the size of the District of Columbia). When he died in 1701, he owned 54,000 acres in Virginia. His will divided Ravensworth equally between his two oldest sons. William Fitzhugh Jr. got the southern half. Henry got the northern part, which became part of Mantua.

Mantua once was a 548.75-acre farm—a small plantation—and a home for several generations of one family. On January 30, 1776, Richard Chichester, born in 1736 to Richard Chichester and Ellen Ball, obtained a Northern Neck land grant. It was described as on a "small branch of Long Branch of Accotink adjacent to land purchased of Richard Watts." Chichester, who lived at Newington in Fairfax County, was a cousin to George Washington through his mother's side. His second wife was Sarah McCarty, the daughter of Daniel McCarty, who had a land grant for 648 acres along the creek. Their son Daniel McCarty Chichester inherited some of the more than 1,000 acres Richard amassed. Daniel passed some of it on to his son George, who built a house and ran a farm in Mantua.

Either Daniel or George named the place "MAN-chew-ahh," like the English pronunciation of the northern Italian city, after a Ball family connection. Twenty-first-century residents call their home "Man-TOO-ahh." George owned and raced horses, married three times, and died insolvent. John Henry Chichester, George's son from his first marriage, lived on the farm and

kept it going with the help of enslaved people. John fought for the South during the Civil War and once hosted a famous general in his mansion. He also fought his father's third wife to keep the farm. John was charged with embezzling government money; his widow paid it back and kept the farm, which got divided six ways. The wood-frame house, dating from the 1820s, was rebuilt. Family members joined forces to run a livestock operation until 1942. Eventually, the family left.

Then World War II arrived, and with it, a growing federal government and defense industry—and the need for more housing. Mantua developed into a suburb about 15 miles west of Washington, DC, because of its enviable location: between the Little River Turnpike (Route 236), a toll road from Alexandria to Aldie that started in 1801, and US Route 50, created in 1926 as part of the national highway system. It was far enough away from the nation's capital to have its own identity, yet good for commuting. The suburb started growing in two sections: north on Chichester land and south among farms off the Little River Turnpike. In between were fields and woods. Developer LeRoy Eakin Sr. was a visionary. He saw Mantua's location and bought pieces of land to create the first subdivision in 1949 on Chichester land. He also donated 15 acres off Glenbrook Road in Mantua in 1951 for the first park in what later became the 23,500-acre Fairfax County Park Authority system.

Mantua's location in Northern Virginia has been enhanced since then because of its access to transportation. The official boundaries are south, Little River Turnpike; north, Arlington Boulevard; east, Prosperity Avenue; and west, almost to Pickett Road, where it abuts the City of Fairfax. The Capital Beltway, Interstate 495, was built two miles east between 1961 and 1964. Interstate 66 reached Washington in 1982, extending the range of places in the metropolitan area within a half-hour commute of Mantua. The Washington Metro—the subway system—has two stops within three miles of Mantua.

Mantua suburb's first houses were mostly three- and four-bedroom ramblers. But unlike some neighborhoods, there was no one house style as it grew; Colonials and contemporaries were built side by side. They were not mass-produced "cookie-cutter" houses without distinguishing characteristics. Small builders bought lots and sometimes showcased new designs.

Demographically, suburb residents had much in common. They were mostly white, held professional jobs, and had children. Today, US Census data indicates that 17.9 percent of Mantua residents are 65 years old or older, 87 percent have university educations, and about 12.4 percent are veterans. The early suburbanites formed a community with groups and clubs based on common interests. Before the Internet and social media, the community newsletter was a key way to share information about potlucks, parades, and neighbors. Most of the Mid-century Modern houses of early residents still exist, many with additions, but each year, several houses get replaced with larger ones.

The neighborhood was shaken in 1990 when a resident discovered an oily sheen on a tributary of the Accotink Creek. An underground oil spill from a petroleum holding facility in the City of Fairfax at the edge of Mantua forced evacuations and relocations. The community was tested. Some residents moved, but others dug in their heels.

The Mantua census tract covers 2.37 square miles, or 1,517 acres. That is not a lot of land when compared with the 17th-century land grants. But much had happened and changed. Here is a look at some of the people and places that shaped it.

One

A GOOD LOCATION

Mantua was part of the five million acres that King Charles II of England awarded to seven loyalists in 1649. It was called the Northern Neck, a portion of Virginia situated between the Potomac and Rappahannock Rivers. Through land patents and grants, that acreage was acquired and inherited, and eventually, Thomas Fairfax, the sixth baron of Cameron, came to live in Virginia. Fairfax County is named for him.

William Fitzhugh, born in England, immigrated to Virginia in 1651. He obtained the 21,996-acre Ravensworth tract in 1685, almost nine percent of the county's total acreage today. When he died in 1701, he owned 54,000 acres, including Ravensworth—37.7 square miles, or about half the size of the District of Columbia. His will divided Ravensworth equally between his two oldest sons. William Jr. got the southern half. The northern part went to Henry, and part of that is today's Mantua, although it was not called that until the next century.

The Accotink Creek flows through the land to the Potomac River, which empties into the Chesapeake Bay. Before English settlers, Native Americans—the Dogues, an Algonquin tribe—camped and fished along its banks.

In January 1776, during the American Revolution, Richard Chichester, a justice of Fairfax County, saw an opportunity in owning land with water. He obtained a Northern Neck land grant for five acres along the Accotink Creek. It was described as a "small branch of Long Branch." He married Sarah, the daughter of Daniel McCarty, who also owned land. Between 1777 and 1787, Richard acquired more than 1,000 acres, including 282 acres of "Accotink Run north of Ravensworth" from Maj. John Fitzhugh, a Fitzhugh descendant. Mantua is a piece of that—1,510.4 acres of land and 13 acres of water.

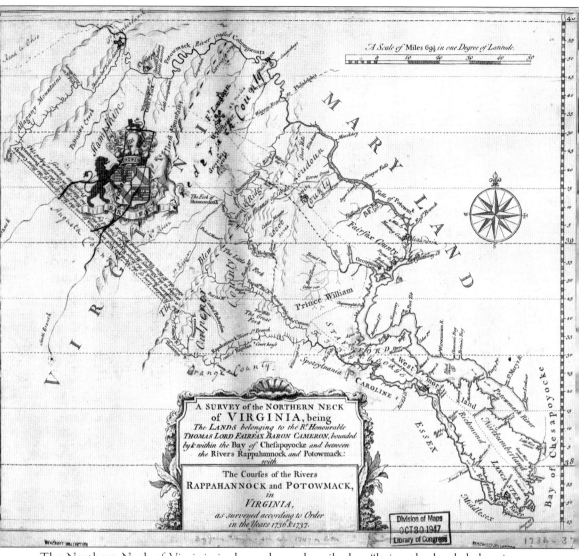

The Northern Neck of Virginia is shown here, described as "being the lands belonging to the Rt. Honourable Thomas Lord Fairfax Baron Cameron, bounded by & within the Bay of Chesapoyocke and between the rivers Rappahannock and Potowmack: With the courses of the rivers Rappahannock and Potowmack, in Virginia, as surveyed according to order in the years 1736 & 1737." Fairfax County is shown on the right. What became Mantua is in the middle of the county. A 1760 map of Fairfax County by Beth Mitchell explained how large the Ravensworth tract was, with Mantua just part of the top. It listed landowners and tenants. Mantua land was owned at that time mostly by John Fitzhugh (from Little River Turnpike to roughly Hamilton Drive) and John Gladdin (into the City of Fairfax). A hundred years later, the tracts had new owners. Part of Mantua shown on 1860 maps are in the following chapters on the Chichesters and Glenbrook Road. (Geography and Map Division, LOC.)

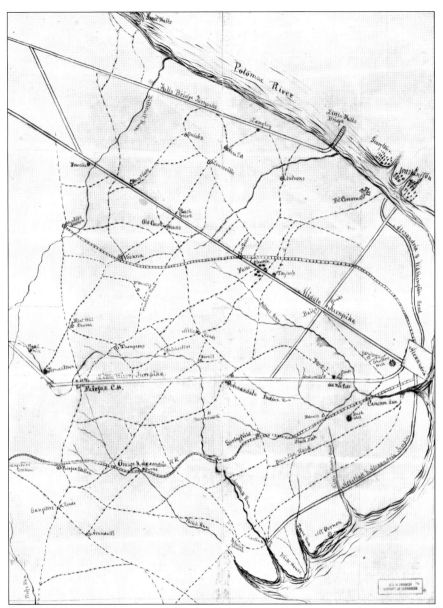

This 1861 Civil War field map of Fairfax County illustrates the strategic location that Mantua had—although early maps do not show a place named Mantua. The map was done to show Fort Corcoran, marked near Washington on the right of the map. Some roads and paths shown no longer exist, but at the center of the map are two early roads: the Little River Turnpike at the south, with Fairfax Courthouse, indicated as Fairfax C.H., and Middle Turnpike in the north. To the north of the Little River Turnpike is an "X" that marks Mills XRoads, and below it to the left is a circle with the word "Chichesters." The Chichester family occupied a house at that location during the Civil War. The squiggly line indicates Accotink Creek, which ran south through the Ravensworth tract. A railroad line ran from Alexandria in the east through Falls Church and Vienna to the west. The Old Court House northeast of Vienna was at Tysons Corner. Mantua was less than three miles from the new courthouse, the site of the Civil War's first casualty. (Geography and Map Division, LOC.)

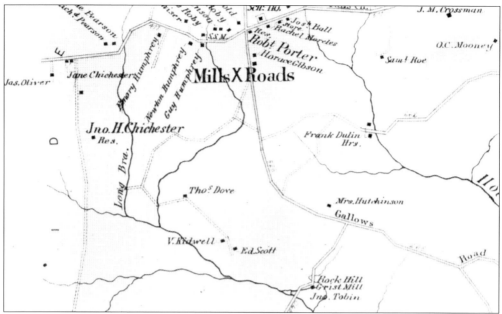

The 1879 map by G.M. Hopkins shows Falls Church District No. 1. It included Mills X Roads, top center, now Merrifield. The road line at the top was the Falls Church and Fairfax Court House Road, which today is Lee Highway. John (Jno) Chichester's residence is marked with a small square left of Long Branch. Above it is his relative Jane Chichester's land. The road to its left became Cedar Lane. (Geography and Map Division, LOC.)

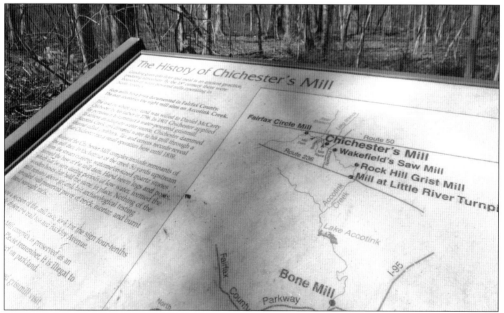

Tobacco was grown in Fairfax County by early settlers, but it depleted the soil. Farmers switched to wheat and corn, easier to grow. Fairfax Circle (Askins') Mill, a gristmill to grind grain, operated around 1801 in Mantua Park, east of Pickett Road. Traces of a mile-long mill race were identified, as this Fairfax County Park Authority marker indicates. An 1862 Civil War map labeled an "old mill" there. (Photograph by the author.)

Daniel McCarty Chichester's mill was on Long Branch around 1801, behind the suburb's Mantua Drive. It was a sawmill, but also ground grain, perhaps alternating in response to the local economy. In 1820, it produced 4,500 bushels of wheat "at an annual cost of $5,625" and employed one man and one woman, according to that year's Census of Manufactures for Fairfax County. The Accotink and its tributaries have changed course over the years due to floods, natural erosion, and suburban development. The miller's house at Chichester's operation would have been perched on a hill not far from a structure that contained the water wheel to power the mill, but no remnants remain. (Both photographs by the author.)

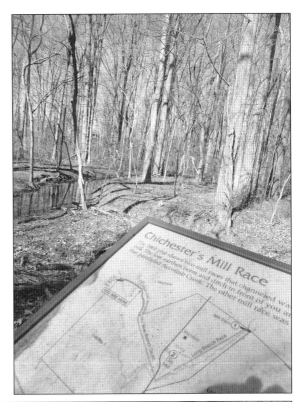

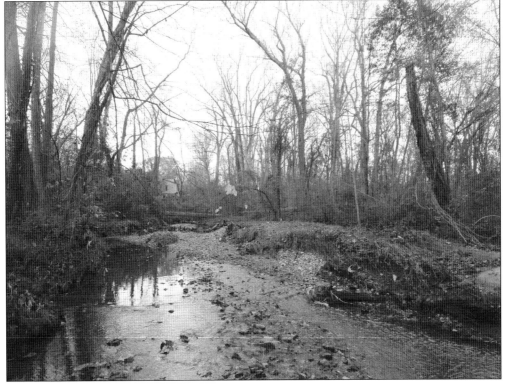

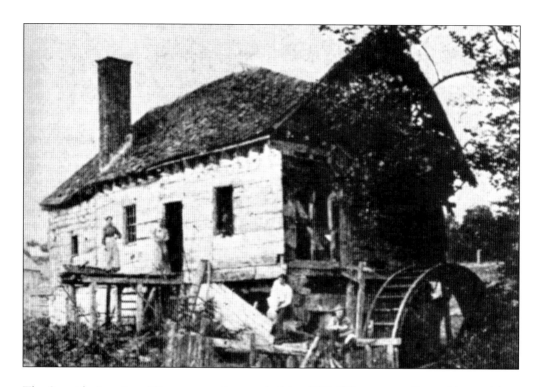

The Spanish-American War came to the area in May 1898. When not at Camp Alger, soldiers explored. Some visited this mill on Accotink Creek. Chaplain Kerlin with the troops described an old mill that "has not ground corn, I presume, for a generation. Its mossy roof threatens to tumble in; the old water wheel is falling to ruin. . . . It is a century and half old. . . . The nails that now but feebly hold the decaying boards to the massive timbers of the frame were hand-made. Visitors esteem these, or a wooden cog, or some other old iron or piece of wood, as a valuable souvenir." In July 1898, soldiers with heat-related illnesses filled hospital tents. "The sun is like a ball of fire," one soldier said. Below are "the boys of the signal corps at mess." (Above, from *City of Canvas* by Noel Garraux Harrison, photograph from Cleveland Plain Dealer; below, FCPLPA.)

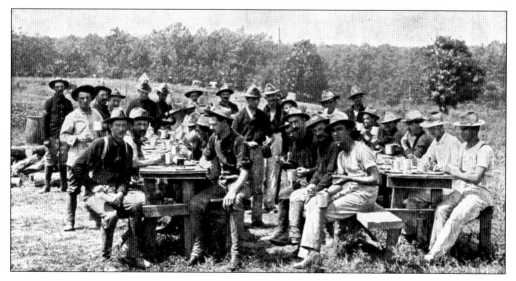

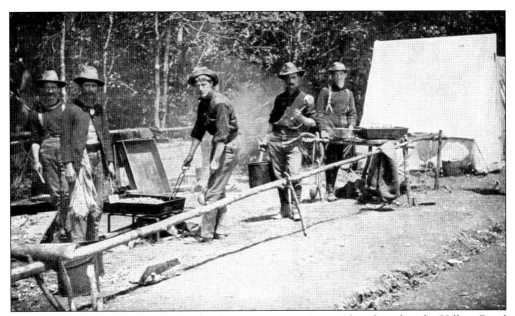

The kitchen of the 1st District of Columbia Regiment at Camp Alger, based in the Hilltop Road and Dorr Avenue area in Merrifield/Dunn Loring, reflects the rough living conditions, a reason why soldiers sought out places like Accotink Creek. The scarcity of water made it difficult for soldiers to attend to their personal hygiene. A typhoid fever epidemic broke out. Chief surgeon Alfred C. Girard bemoaned the lack of medical personnel or facilities. Woodburn Manor, a 1,400-acre farm two miles west of the town of Falls Church, became a training center for more than 23,000 soldiers from 16 states. Thirty-two units were scattered from there down to what is now Falls Church High School to the east. The camp stretched from Falls Church around Lee Highway north to the Inova Fairfax Hospital area south. (Both, FCPLPA.)

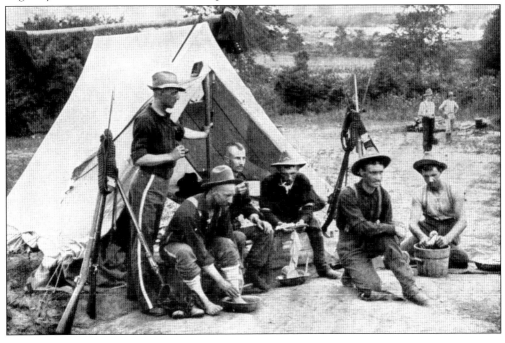

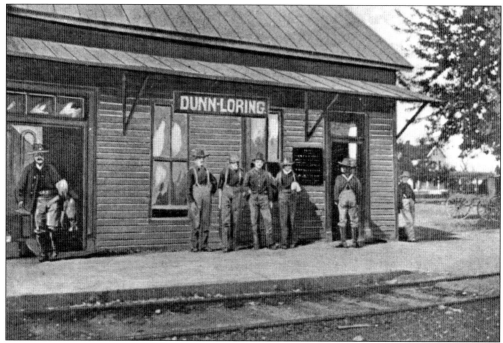

The Southern railway corridor that ran west from Washington, DC, and Alexandria was a crucial transportation hub during the Spanish-American War. Troops arrived at Dunn Loring station, shown above with soldiers on the platform. Cold-storage rail cars brought the Armour packing company's beef to Dunn Loring, about 65,000 pounds every week. The East Falls Church railroad station, below, was also busy with troops arriving and leaving. Both Falls Church and Dunn Loring were located less than a mile from the center of Camp Alger. Enterprising local residents earned cash as hack drivers, such as the many in vehicles shown here, to drive soldiers to and from camp. (Both, FCPLPA.)

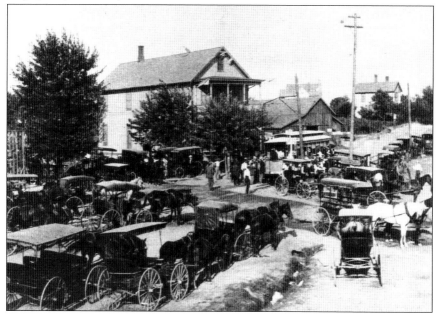

Two

THE CHICHESTERS

In the early 19th century, Mantua was the home of George Chichester and his family. Cows roamed pastures, and wheat grew in fields around a farm with what was described as a mansion house. By today's standards, the house would be considered modest—six rooms, including the attic.

George's father, Daniel McCarty Chichester, built two mills along the Accotink Creek. The Chichester family had been in the colonies since the 17th century. Richard Chichester (1736–1796), the second son of Richard Chichester and Ellen Ball, had a reputation as a demanding person. His second wife was Sarah McCarty, whose family had a 522-acre Fairfax County tract patented in 1727, now Mount Air historic site. Richard was referred to as "colonel" for his assistance during the American Revolution; he provided 272 bushels of corn to Gen. Lafayette's troops when they passed through the town of Colchester (near Occoquan) on their way to Yorktown. He once wrote to George Washington about hunting deer at Mount Vernon. Richard was a justice of the Fairfax County Court, tax collector, and census taker.

George Chichester and his son John Henry raised cattle and hogs and grew wheat. George trained and raced horses. Before the Civil War, enslaved people worked on the 548-acre farm (some deeds add an extra half or three-quarter acre). John voted for secession from the Union at Fairfax Court House, where the first Confederate soldier was killed. He served in the South's army, and a general once supped at his manor. He returned home but tried to sell the farm, then managed by the courts. He was elected county treasurer in 1874, a job he held until he died. After a long and bitter court struggle with his father's third wife, Sarah Ellen Dulany Chichester, who married John in 1854, was awarded part of the farm. But she had another battle to face: John was charged with embezzling government funds. He died, and his widow was obligated to repay them. There was little left of his estate.

The land was divided in 1898 among John and Sarah's six daughters. Here is a look at their times.

George Chichester was a farmer who also raised, boarded, and trained horses. Above is an excerpt of his account with William Duvall, who owned adjacent land (near today's Duvall Street). In 1841, George asked for services "for training one filly," including water, oats, and horse-shoeing. The two disputed costs and wound up in court. Below, George and his son John agreed to pay $45 for the hire of "Negro Thomas Parne" for one year. They agreed to furnish him with "three shirts, two pair pants of good cotton pants, one pair of shoes for summer, coats vest pants of good piled cloth and Hat Blanket two pairs socks a pair of good double soled boots for winter all of good quality. The said negro is to be treated with humanity and returned on or before the 25th of December 1847." (Both, Fairfax Circuit Court Historic Records Center.)

SCHEDULE 2.—Slave Inhabitants in _____ in the County of *Fairfax* Sta of *Virginia*; enumerated by me, on the *16th* day of *September*, 1850. *Wilmer McLean* Ass't Marsh.

NAMES OF SLAVE OWNERS.	Number of Slaves	Age.	Sex.	Colour.	Fugitives from the State.	Number manumitted.	Deaf & dumb, blind, insane, or idiotic.	NAMES OF SLAVE OWNERS.	Number of Slaves	Age.	Sex.	Colour.	Fugitives from the State.	Number manumitted.	Deaf & du. blind, in or idiotic.	
1		1	10	M	B				1	1	15	M	B			
2		1	5	M	B				2	1	12	M	B			
263 Wesley Hutchinson	1	35	F	M				Basil Gaul	1	60	M	B				
4		1	40	F	M				1	40	F	M				
5		1	30	M	B				1	36	M	B				
6		1	9	F	B				1	12	F	B				
7		1	5	M	B				1	6	M	B		Dfd De		
264 Nathaniel Carroll	1	35	F	B				1	5	F	B					
9		1	5	M	B				1	3	M	B				
265 Tapley Reader	1	15	F	B			William R. Slade	1	40	M	B					
11		1	37	M	M				1	8	M	B				
12		1	10	F	B				1	1	F	B				
266 John R. Single	1	40	M	M			Edward McHerbany	1	30	M	B					
14		1	40	M	B				1	15	M	B				
15		1	30	F	M			Benjamin F. Marshall	1	37	M	B				
16		1	16	M	M				1	53	M	B				
17		1	8	M	M				1	48	F	B				
18		1	6	F	M				1	40	M	B				
19		1	2	F	M				1	17	M	B				
267 Harrison E. Howard	1	50	M	B				1	13	M	B					
21		1	16	F	B				1	10	M	B				
268 John H. Chichester	1	60	M	B			John Slalout	1	31	M	B					
23		1	58	M	B			William Slalout	1	25	M	B				
24		1	50	F	B				1	15	F	B				
25		1	55	F	M				1	30	F	M				
26		1	65	M	B				1	7	M	M				
27		1	33	F	B				1	1	M	M				
28		1	33	M	M			William Means	1	37	M	B				
29		1	23	M	B				1	27	F	B				
30		1	30	M	M				1	19	M	B				
31		1	11	M	B				1	3	F	B				
32		1	10	M	B			Robert Gunnell	1	40	M	M				
33		1	9	M	M			Henry Johnson	1	20	F	B				
34		1	8	F	B				1	1	M	B				
35		1	7	M	M			Daniel F. Dulany	1	23	F	B				
36		1	4	M	M				1	34	M	M				
37		1	2	F	M				1	16	F	B				
269 William Swink	1	95	F	B			Hornetta Reid	1	31	M	B					
39		1	60	M	B				1	27	F	B				
40									1	2	M	M				
41									1	4/12	F	M				
42								Richard S. Reid	1	24	M	B				

Enslaved people worked on the 548-acre Mantua farm, a sizeable operation. The September 16, 1850, list of "slave inhabitants" identified John H. Chichester, age 35, as a slave owner. Sixteen enslaved people, identified as either Black or mulatto, ranged in age from two to 60. The 1860 census lists John as a farmer with four female slaves ages 30, 9, 3, and 1. (One enslaved woman named Julia was born in Fairfax County in 1859.) His property was valued at $13,000 for 288–300 acres. Chichester owned 8 horses, 6 milk cows, 2 ass/mules, 2 working oxen, 15 cattle, 9 sheep, 80 hogs, and livestock valued at $1,500; he produced rye, 50 bushels; Indian corn, 250 bushels; oats, 200 bushels; wool, 30 pounds; Irish potatoes, 200 bushels; and hay, 10 tons. When the Civil War arrived, the farm was operating with far fewer resources than a decade earlier. In 1863, John paid taxes for one enslaved person, three horses, one cow, five cattle, five hogs, one watch, one clock, and furniture valued at $103. (Fairfax County Slave Schedule, Agricultural Census, 1863 property tax.)

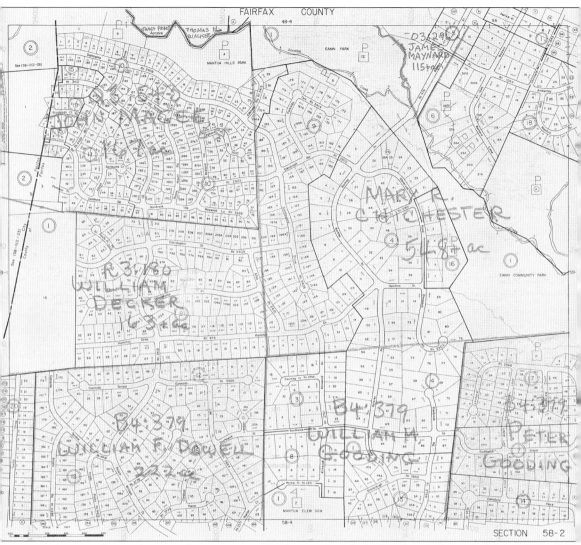

This map shows who owned some Mantua land in 1860, right before the Civil War. The number above the name is the Fairfax County deed book and page. Mary Rebecca (Corse) Chichester owned 548 acres after her husband, George, died in 1858. George married her on July 12, 1857. He had three children with his first wife, Margaret Payton, and six with his second, Mary Dent. George's will, written in 1856, instructed Mary R. "that there be no sale of any part of my property, unless for the purpose of reinvesting it in an advantageous or profitable property." John Henry Chichester, George's son from his first marriage, was living at Mantua with his wife and three children. George also owned land in Loudoun County and Hinds County, Mississippi, where he died at age 61 of liver problems. His estate listed 12 enslaved persons: "Bitty and children Annor and Margaret 100 ($)100; Nelly 400; Emily 700; Eliza and Child 850; Ned 800; Jatson 900; John 700; Solomon 850; Peter 50." (Fairfax County in 1860 map by Beth Mitchell and Edith Moore Sprouse, Fairfax County History Commission.)

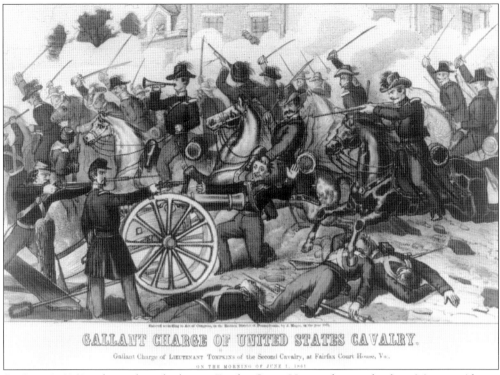

Gallant Charge of LIEUTENANT TOMPKINS of the Second Cavalry, at Fairfax Court House, Va.
ON THE MORNING OF JUNE 1, 1861.

On June 1, 1861, a skirmish took place at Fairfax Court House, three miles from Mantua. Above, "Gallant Charge of Lieutenant Tompkins of the Second Cavalry" by James Magee depicts Lt. Charles H. Tompkins, who led a Union cavalry patrol that clashed with Confederates. Tompkins had been sent to estimate enemy troops in the area. John H. Chichester had voted for Virginia's secession from the Union at the courthouse. The monument erected to Confederate States of America captain John Quincy Marr, the first Confederate killed during the Civil War, was removed from the Fairfax Court House in 2020 by the Fairfax County Board of Supervisors. He was captain of the Warrenton Rifles (17th Virginia Infantry, Company K) and was killed on June 1, 1861. His body was found the next day. He was buried in Warrenton, Virginia, his hometown. (Above, Prints and Photographs Division, LOC; below, photograph by the author.)

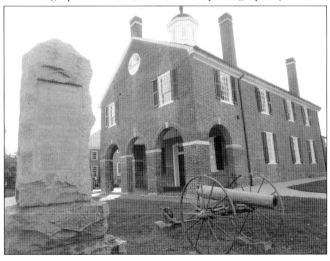

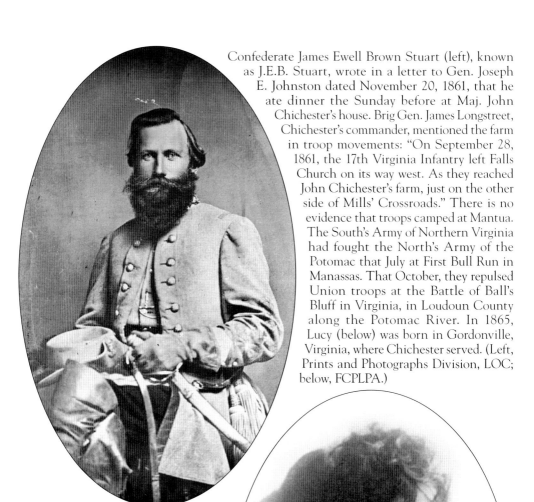

Confederate James Ewell Brown Stuart (left), known as J.E.B. Stuart, wrote in a letter to Gen. Joseph E. Johnston dated November 20, 1861, that he ate dinner the Sunday before at Maj. John Chichester's house. Brig Gen. James Longstreet, Chichester's commander, mentioned the farm in troop movements: "On September 28, 1861, the 17th Virginia Infantry left Falls Church on its way west. As they reached John Chichester's farm, just on the other side of Mills' Crossroads." There is no evidence that troops camped at Mantua. The South's Army of Northern Virginia had fought the North's Army of the Potomac that July at First Bull Run in Manassas. That October, they repulsed Union troops at the Battle of Ball's Bluff in Virginia, in Loudoun County along the Potomac River. In 1865, Lucy (below) was born in Gordonville, Virginia, where Chichester served. (Left, Prints and Photographs Division, LOC; below, FCPLPA.)

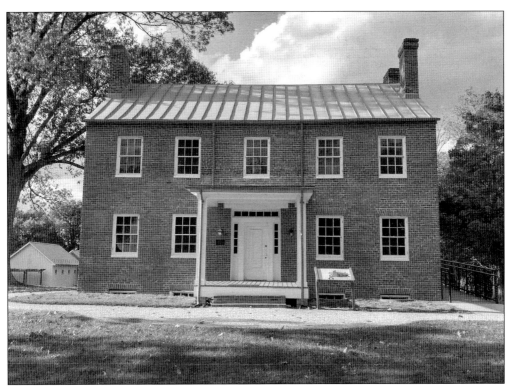

At the start of the Civil War, Albert Willcoxon owned Blenheim, above, a c. 1859 Greek Revival–style brick farmhouse at 3610 Old Lee Highway, now a historic site west of Mantua. Union troops used it as a hospital. Soldier graffiti on the walls have been preserved. In September 1862, John Chichester wrote his wife from Frederick City, Maryland, "O the horrible sights . . . some shot in two, others with their legs and arms shot off." Eliza J. Seale worked as an enslaved woman at Blenheim before the Civil War. Afterward, she worked for the Chichester family. This December 7, 1882, marriage certificate shows that at age 21, she married Richard Odricks, a farmer, of Vienna in Fairfax County. She is listed in the 1880 federal census as residing with the Chichesters. (Both, courtesy of City of Fairfax Collections.)

DVERTISER.

LOCAL BREVITIES.

We regret to record the death of Mrs. Mary R. Chichester, widow of the late Capt. Chichester, of Fairfax county. She died at her residence in Fairfax on Thursday last. Sometime since she was injured by being run over by a wagon in Washington, and had been a sufferer ever since—never entirely recovering from the shock. She was a most estimable and esteemed lady.

John Chichester was relieved from duty as commissary of subsistence for the Right Wing, Army of Northern Virginia, in November 1862 and ordered in September 1863 to report to Gordonville. He was paroled on June 3, 1865. His father's wife had inherited the farm. In 1873, she died after being run over by a wagon. In December 1874, according to the *Fairfax News*, John tried to rent Mantua, then managed by the courts: "This farm lies on Accotink Run, has thereon a large frame dwelling, barn stables, with all the usual outbuildings, a grist and sawmill. The soil is well adapted to grass, grain and fruit. Much of this farm is covered with timber, perhaps the most valuable in the county. Contains 548 ¾ acres." John and his family (Ellen May, shown here around 1875) farmed. He was elected county treasurer in 1874. (Above, the *Alexandria Gazette and Virginia Advertiser*; below, FCPLPA.)

Page No. 2

Supervisor's Dist. No. 4

Enumeration Dist. No. 37

Note A.—The Census Year begins June 1, 1879, and ends May 31, 1880.

Note B.—All persons will be included in the Enumeration who were living on the 1st day of June, 1880. No others will. Children BORN SINCE June 1, 1880, will be OMITTED. Members of Families who have DIED SINCE June 1, 1880, will be INCLUDED.

Note C.—Questions Nos. 13, 14, 22 and 23 are not to be asked in respect to persons under 10 years of age.

SCHEDULE I.—Inhabitants in Falls Church District, in the County of Fairfax, State of Virginia, enumerated by me on the 9th day of June, 1880.

J. M. Thorne

[The main body of this page is a handwritten 1880 US Census schedule listing inhabitants of Falls Church District, Fairfax County, Virginia. The handwriting is too faint and degraded for reliable transcription of individual entries.]

John Chichester, a lawyer, had been admitted to the Fairfax County bar in December 1846. When he ran for reelection as county treasurer in 1887, his opponent accused him of being lenient with people who had trouble paying taxes. The *Fairfax Herald* editor defended him: "There is no kinder-hearted officer in the state than Major Chichester. He is the poor man's friend. . . . The major's leniency occasions no loss to the County. Where he neglects to collect a bill that can be made, be becomes individually responsible to the county and the State for the amount, and his responsibility is assured by one of the best bonds that an officer could possible execute." The June 8, 1880, US Census lists John H. Chichester (on line 31) as both county treasurer and farmer. Thirteen people lived in his household, including wife Sarah E. (Dulany), six daughters, six-month-old niece Nannie, deputy county treasurer Terrett Washington (age 22), and three Black servants: Jeter Tillman (age 13) and Johnson Alec (35), both farm laborers, and Eliza Seales (18, formerly of Blenheim), identified as a domestic servant. (US Census.)

The second-oldest Chichester daughter, Margaret Tingey, called "Madge," is shown here as a young woman and at her wedding. She married James Maynadier Mason of Walnut Hill on October 8, 1884, at the Falls Church. They had two children: Ellen Dulany "Nellie" Mason and James Maynadier Mason. Madge and her husband tried to keep the Mantua farm operating with other relatives after it did not sell. In 1889, John Chichester was accused by the Commonwealth of Virginia of not carrying out his duties as county treasurer and school board clerk—of embezzling money. He "unlawfully appropriated for his own use," the lawsuit stated, funds for seven school districts. The county sued for $100,000, the amount of the error they claimed he made since 1881. He died at age 66 "at Mantua" of gastric fever (typhoid) on June 27, 1889. (FCPLPA.)

John Henry Chichester died at age 66. His monument in the Falls Church Cemetery, shown here during the Civil War, is in front of the tree on the right. It reads, "A Devoted Husband and Father a True Friend and Useful Citizen." John had not made a last will and testament. No photograph of him has been located. (Prints and Photographs Division, LOC.)

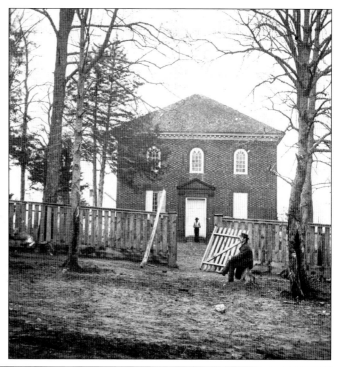

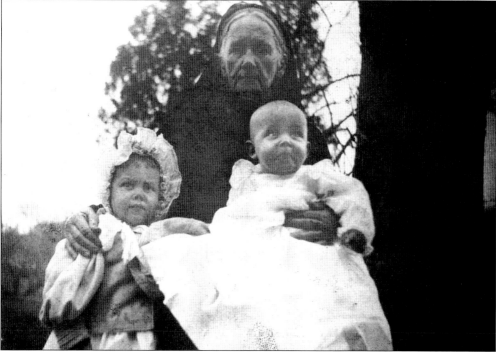

This photograph of Sarah Dulany Chichester with two grandchildren was taken shortly after John died; she is wearing black mourning clothes. Sarah was obligated to pay back the funds John was accused of taking. His estate, probated in November 1891, left her virtually nothing. She sold 74 acres of the farm at $5 per acre at public auction in 1896. (FCPLPA.)

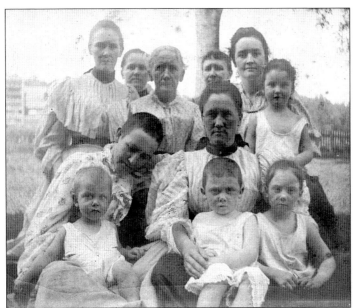

"Ma" Sarah Dulany Chichester is surrounded by her daughters and grandchildren. Pictured from left to right are (first row) Lucy "Dottie" Mackall, James Mason and Ellen Dulany "Nellie" Mason; (second row) Lucy Mackall and Margaret "Madge" Mason; (third row) Sarah "Sallie" Loving, Henrietta "Etta" Chichester, Ma, Ellen May "Mamie" Chichester, and Mary "Minnie" Davidson. Cows were kept in the field nearby, west of the house. (FCPLPA.)

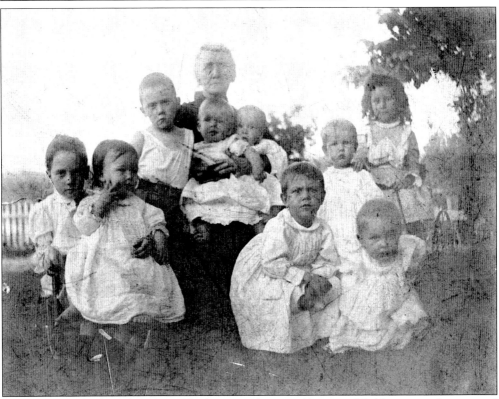

This photograph of Sarah Dulany Chichester with nine of her grandchildren was taken around 1900. The Chichester family grew after daughters married. Lucy and Sallie had a double wedding on April 4, 1893, in Washington. Lucy married Douglass Sorrel Mackall. Sallie married Samuel Bridges Loving. Their sister Minnie and her husband, John Davidson, held a reception afterward at their Q Street home. (FCPLPA.)

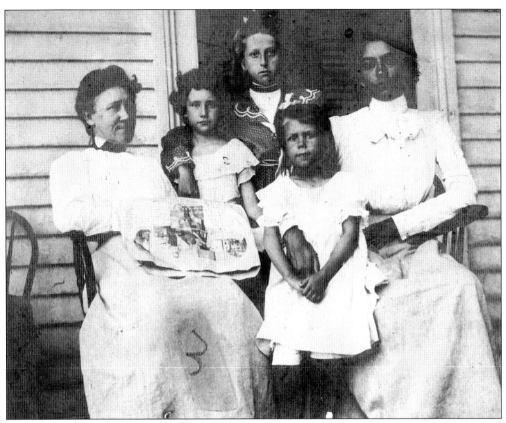

On the porch of the farmhouse around 1900 are, from left to right, Lucy Hunter Chichester Mackall with Nellie Davidson, Louise Davidson, Dottie Mackall, and Polly Fitzhugh, a family friend. The porch wood was wide white shiplap, and dark-painted working shutters still existed. The *Alexandria Gazette* reported in 1956 that the house was constructed "sometime before 1743," which is not confirmed by historical records. (FCPLPA.)

Lucy Hunter Chichester Mackall, in back, is shown at Mantua farm with, from left, Ellen Dulany (Nellie) Mason; her daughter Dottie Mackall, on her lap, wearing a bonnet; and her nephew James M. Mason (in hat). Lucy married Douglass Sorrel Mackall and moved to Washington, DC. They had five children. (FCPLPA.)

Sarah Dulany Chichester, the older woman pictured above in center front holding a baby, is shown on the front porch of the Mantua house surrounded by her daughters and grandchildren around the year 1905. The white wood pillars were replaced in the 1930s after the house was renovated. They were enclosed by Rahe and Lois Miller, who bought some of what was left of the farm in 1956. At left, some of the Chichester grandchildren (likely the Davidsons) pose on the farm with the family dog for a holiday card with a green and red decorative border. It was sent to family and friends sometime around the year 1910. Another photograph from the same time shows a chocolate-colored Labrador retriever roaming the farm. The family raised cattle and grew vegetables. (Both, FCPLPA.)

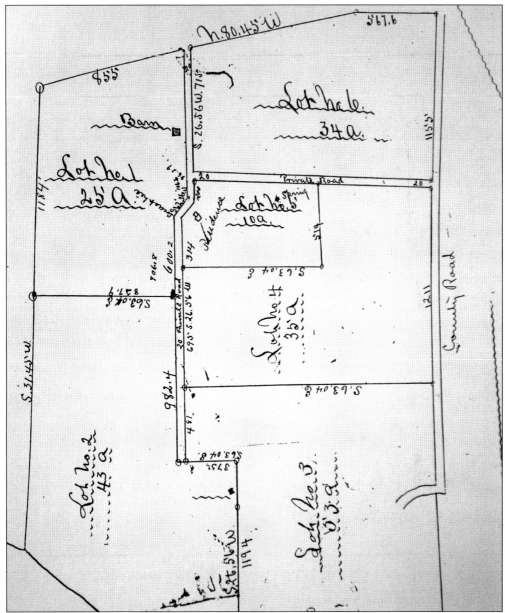

In 1873, after Mary R. Chichester died, Sarah enlisted the help of agent Arthur Herbert to obtain ownership. In 1883 the court awarded her 202.75 of George Chichester's 548 acres. In 1880, Herbert had bought 345 acres for $11 an acre. H. Grafton Dulany held the warranty. After John died in 1889, Sarah stayed on the farm. Sarah divided the farm in 1898 among her six daughters. This plat shows the deed of partition. Minnie (Chichester) Davidson was given Lot 5 and the family house on 10 acres. It had a spring and access on two private roads. Lot 1, 25 acres and the barn, was along Lee Boulevard (later called Arlington Boulevard) and went to Ellen Mary, who signed her name as E. May and was called "Mamie;" Lot 2, 43 acres, went to Lucy C. Mackall; Lot 3, 53 acres, which stretched south to the Accotink Creek, went to Sallie Loving; Lot 4, 35 acres, went to Madge Mason; and Lot 6, 34 acres, went to Etta. Etta and Mamie never married. (Fairfax Circuit Court Historic Records Center.)

In the photograph above, Sarah Dulany Chichester (center) is shielded from the sun by a parasol held by her daughter Minnie (Chichester) Davidson (right); the identity of the other woman is unknown. An article on July 4, 1901, in the *Washington Post* reported that Washington people registered at Atlantic City hotels included at the "Clarendon—Mr. and Mrs. John Davidson and Mrs. S.E. Chichester." The hotel was on the beach and had an elevator. Below, John C. Davidson and Ellen "Nellie" Davidson play in the ocean around 1892. The wooden pedestrian pier in the background may have been at Atlantic City. The *Washington Post* reported, "While all the great cities have been suffering with the heat this week, Atlantic City has been cool three-fourths of the time." (Both, FCPLPA.)

Several Chichester daughters may have taken beach vacations together in the early 20th century. Above, Douglass Sorrel Mackall, the husband of Lucy Hunter Chichester, poses with some of the children near a pedestrian boardwalk that may have been at Atlantic City (or Cape May, another family vacation spot) in New Jersey. The *Washington Post* reported that over the Fourth of July, "trains from New York, Washington, Baltimore and Philadelphia have filled hotels, Boardwalk and piers." (FCPLPA.)

Minnie Davidson (left), with her husband John C. Davidson and friend Polly Fitzhugh, pose on the sand. This may have been taken at Atlantic City but could have been taken at Cape May, New Jersey; a photograph of Congress Hall (not shown here but in a family album), a hotel at the resort, may have been taken on the same vacation. (FCPLPA.)

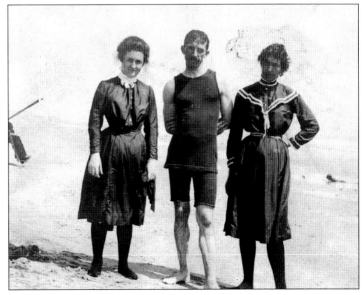

John H. Davidson (left), son of John and Minnie Davidson, likely learned to hunt on the Mantua farm and, when older, accompanied his father and other family members. Here, in a November 1897 photograph, the youngster holds a shotgun much longer than he is tall. He appears to be wearing an adult hunting jacket. Below, John C. Davidson and a hunting dog are shown around 1900. The Mantua farm and surrounding area were both woods and pasture at the time. Davidson and other family members hunted small game, like birds, but also wild turkeys and raccoons in the area. The last wild turkey hunt in Mantua reportedly took place in the early 1950s, but in southern Mantua, closer to the Little River Turnpike area. (Both, FCPLPA.)

Hunters employed helpers. Here, a man who helped during a hunt carries shotgun shells and the game that the hunters, John C. Davidson and others, killed. When this photograph was taken, the Mantua farm was a private hunting ground for the family and their friends. (FCPLPA.)

There were wooded areas, especially along the Accotink Creek and in what is now Mantua Hills subdivisions, but much of Mantua was farmland until the early 20th century. Here, a photograph taken sometime between 1900 and 1920 shows cows grazing in an open field on Chichester land. This image was captured along what is now Barkley Drive and Barbara Lane. (FCPLPA.)

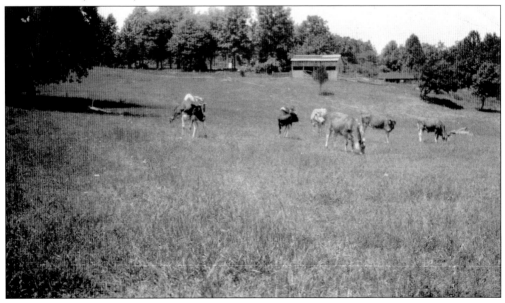

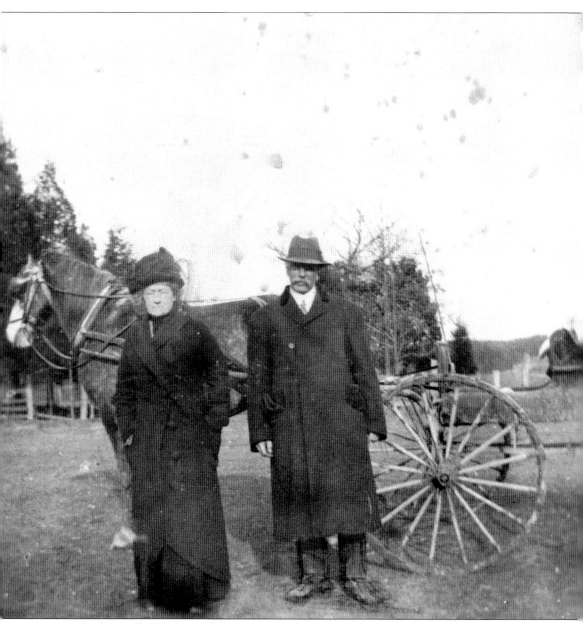

Etta Chichester (left) inherited Lot 6, near Arlington Boulevard. In 1908, a fire broke out in the rear of her house while she was out. Her sister Mamie, who lived nearby, and Mary (Ball) Gillmore saved "several fine horses that were imprisoned in a stable just in the rear of the house." Jefferson D. Lane (right, listed with Etta in the 1910 census) "stumbled and fell headfirst into an old well" 40 feet deep, the Washington Post reported. "The temperature was several degrees below freezing point." His shouts were not heard at first because of the commotion. The women improvised straps from harnesses to lift him out. "The man was badly damaged by the flames, which for a time threatened destruction of the entire building," the Post said. A bucket brigade of water formed to extinguish the fire. The *Fairfax Herald* reported, "The mansion was badly damaged by the flames, which for a time threatened destruction of the entire building, in which there are costly furnishings and artworks." Furniture burned, a loss valued at $900. (FCPLPA.)

The photograph to the right shows a side view of the wood frame of the Chichester house during renovation in the early 20th century. The man in the right-side downstairs window and the couple in the photograph below are unidentified. In the image below, the porch pillars have been removed. The age of the house from property records indicates inconclusively that the structure might have been built as early as 1820. John Henry Chichester was born on the farm in 1824, which means his father, George, may have had it built. When it was renovated, it might have been 100 years old. Photographs here are part of the collection compiled by family descendants Henry C. Mackall, whose mother was Lucy Hunter Chichester, and John C. Davidson, who married Minnie Chichester. (Both, FCPLPA.)

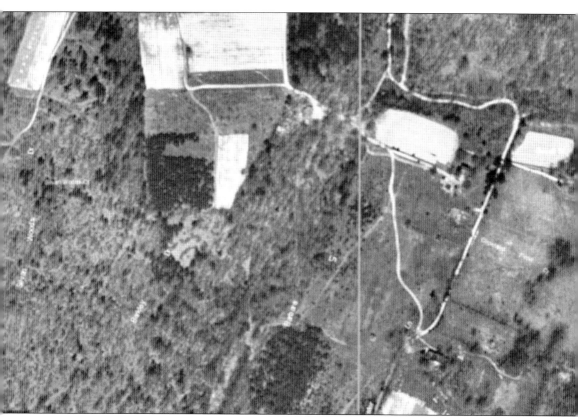

This 1937 view shows Mantua Farms Incorporated. In 1921, Ellen May Chichester conveyed 17.21 acres to John H. Davidson, her nephew. That same year, Henrietta Chichester, James M. Mason, and John H. Davidson formed Mantua Farms "to buy, sell, breed and deal in livestock." Real estate holdings would be limited to 500 acres. In 1929, Mantua Farms was listed in the *Fairfax Herald* for delinquent land taxes on three parcels: 35 acres, 39 acres, and 17.21 acres. In 1939, Mason and Davidson tried to sell Mantua Farms at auction. The livestock barn was located close to Lee (Arlington) Boulevard. By 1942, Mantua Farms had failed to pay its annual State Corporation Commission license fee and was out of business. Pieces of the farm were sold just years before World War II when a housing boom would make land valuable. (Fairfax County Historic Aerials.)

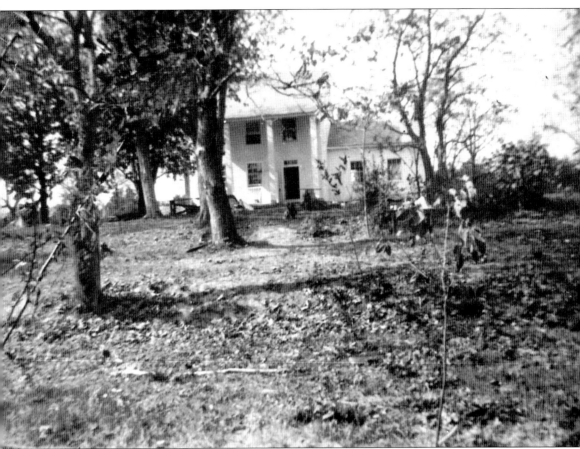

The wood-frame house on Chichester Lane is shown here around the year 1930, after renovation. The house consisted of the part on the left, which had five rooms counting the attic, plus a kitchen, right, with a fireplace. The house was on Minnie Davidson's 10-acre lot in the 1898 deed of partition. A family descendant said the front of the house faced west, as seen above; the back of the house is what suburban residents saw. A descendant remembers that there were "terraces down to a spring" and that his older brothers had to cut the grass there. The spring was mapped on the 1898 division (and may well be an old pond on an adjacent property), as was a large locust tree at the bend of Chichester Lane near Barbara Lane. There was a circular driveway at the front of the house at one point, with access from a road onto what became Amberley Lane. (Mary Davidson Wagaman.)

Seen at left, Ida Parker Davidson and her husband, Heath Dulany Davidson, bought the old Chichester house and 10 acres of land in 1941 from Heath's mother, Mary Chichester Davidson, shown below holding her granddaughter, Mary Davidson. Mary is seated on a wooden Adirondack chair at the back of the house on Mantua farm in 1843. Ida and Heath lived there for a few years but later moved and rented the farm. The farm by then had been subdivided. The two Chichester sisters who never married, Etta and Mamie, lived in houses on the lots given to them in the 1898 subdivision. (Both, Mary Davidson Wagaman.)

Pictured right, Mary Davidson (later Wagaman) poses at the Mantua farm in 1946 with one of the workers, who is holding a bottle of soda pop or beer. By then, the farm was a small private family operation, she remembers, but laborers would be employed to help. The line of laundry hanging in the back is where Barbara Lane's houses stand today. (Mary Davidson Wagaman.)

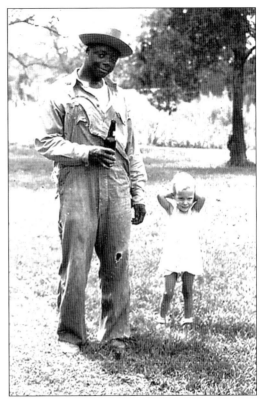

At left, little Mary stands outside the screen back door of the kitchen of the white-painted house around the year 1946. The produce from the family garden, mostly summer squash, is in the cardboard boxes. The family garden was located to the southwest of the back of the house, Wagaman said. The small wooden porch seen here was gone by the 1970s. (Mary Davidson Wagaman.)

Heath Dulany Davidson Jr. (left), born in June 1926, went by the name Dulany. He served in World War II in 1944. On a visit to the Mantua farm, he holds his sister Mary (Davidson) Wagaman. Mary's other brother, Henry Parker Davidson, born in 1927, also served. He listed his employer as the Washington Loan and Trust Company on his draft registration card. (Mary Davidson Wagaman.)

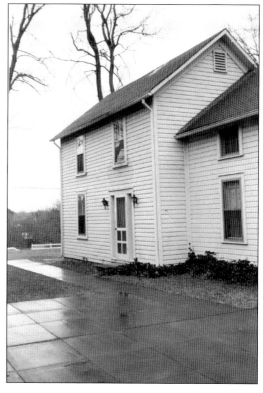

The Fairfax Circle Baptist Church was built on land that once was part of the 548-acre Mantua farm in the 19th century. The land was owned by Etta Chichester, the daughter of John Henry and Sarah Dulany Chichester, after the subdivision. This wood-frame house, painted yellow for years, was a residence on the land when the church bought it. It was removed around 2005. (FCPLPA.)

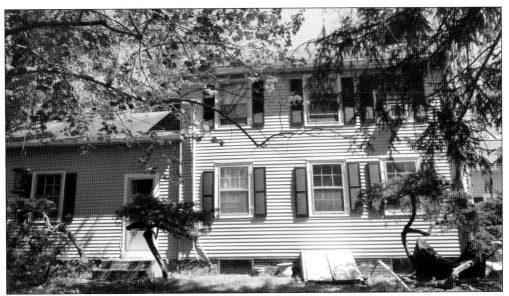

The Chichester house is pictured above. It had two stories plus an attic and a cellar. The 1930s renovation had included wide wood siding on the exterior, which was replaced later with aluminum. Four fireplaces in the rooms shared one flue. A kitchen fireplace heated that room. The main staircase was right of the front door. Wide-plank wood floors from the 1820s may have existed in one room of the house before it was demolished in 2020. Strap-hinge hardware from around 1820 existed. (Photograph by the author.)

Until about the 1970s, this stable building on the original mansion lot, shown here, was used for family horses. The stable was enclosed and enlarged in the late 20th century so that it could be used as a guest house or second residence. The modest renovation left doorways where three horse stalls had previously existed. (Photograph by the author.)

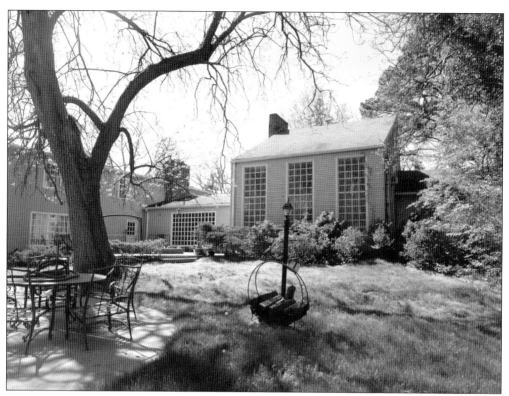

The Chichester house, shown above, was bought in 1956 by Lois and Rahe Miller, who expanded it with two additions, at left and center. It added more bedrooms, a study, and an inviting front entry with a window that showcased the backyard with a patio and pool. The entry joined the old and new sections of the house. A hole was cut through the original house side to give access into the new room. This is a view of the original front of the house that faced the east, where a road had existed in the 1800s when the Chichester family owned it. As seen at left, the original Chichester house had a front porch wide enough for rocking chairs. The wood porch was removed, and the area that had been the porch enclosed when the Millers bought it and turned into a sunroom, shown here. (Both photographs by the author.)

Three

GLENBROOK ROAD

Ever heard of anyone living in a converted chicken coop? Annabelle Myers, born in 1932 in her Grandma Myers's house a few miles away in Oakton, did. Her family lived in a chicken house her father built on the farm that became the Ridgelea Hills subdivision. He moved it down the Little River Turnpike in the early 1940s so his family had something to live in before they could afford to build a house. Elizabeth Walters Smith and her family later lived in that chicken house, too.

While the Chichester family had a livestock operation off Arlington Boulevard, on Mantua's north side, Annabelle's family lived in the area developing to the south along Little River Turnpike, State Route 236. Glenbrook Road, a dirt lane where farm workhorses trod to and fro, got widened in the 1940s to start a new subdivision called Sunny Hill. Like its name, the land sloped upwards to the turnpike.

Annabelle Myers (now Royston-Linden) moved to Glenbrook Road from that farm a few miles east on the turnpike. The east side of the road became the Sunny Hill subdivision. Annabelle married Marshall Royston in 1951 and moved with him to Mount Rainer, Maryland, for a year. She was back a year later and has lived on Glenbrook Road ever since.

Others who grew up on Glenbrook Road include Martha Janet Close, a teacher at Mantua Elementary who worked for Fairfax County Public Schools for 31 years until her retirement in 2000. Her parents, Ross and Janet Close, built a house there in 1947. In 1949, when she was almost four, her parents moved from Norfolk. She remembers when Glenbrook Road got paved: "When the tar was bubbling up, we would play in it by popping bubbles." She remembers a two-acre pig farm across the street and "a huge barn across from where the YMCA was."

Glenbrook Road today is three sections separated by the Crook Branch tributary of Accotink Creek and parkland, but it all started off the turnpike.

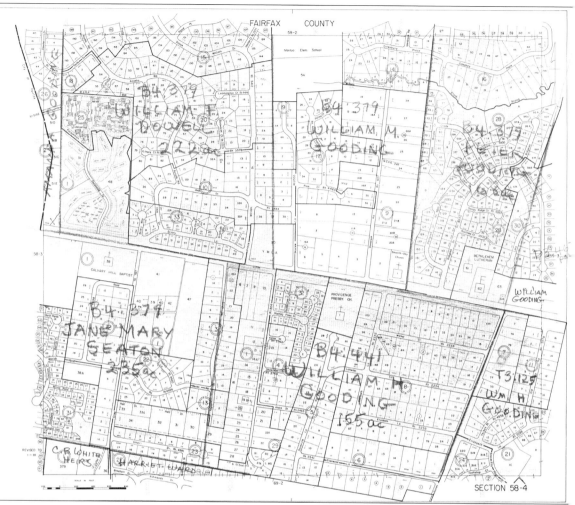

This map of Fairfax County property owners in 1860 is laid over today's streets and shows who owned the land that became Glenbrook Road and the Ridgelea Hills subdivision. The middle of the map is a horizontal line designating the Little River Turnpike. Above that line is Mantua. William M. Gooding's land included what became Glenbrook Road; the number above the name corresponds to Fairfax County Deed Book B4, page 379. William F. Dowell and Peter Gooding also owned land in Mantua. The land where the elementary school is located, top middle of the map, was later owned by the Dove family, who bought it in 1922. The west side of Glenbrook Road is Providence District. The east side is Mason, as is Ridgelea Hills. Across the turnpike was Ilda, a small racially mixed community near the Guinea Road intersection started by freedmen Horace Gibson and Moses Parker after the Civil War. It lasted in the early part of the 20th century. They purchased land from the Gooding family and built a blacksmith shop. It had a post office. (Fairfax County History Commission.)

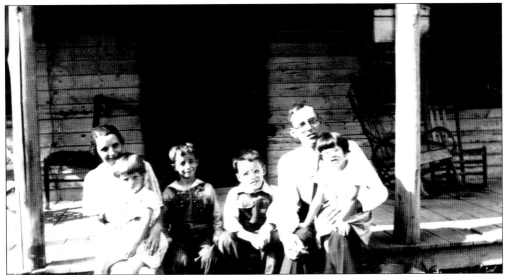

In 1937, Annie and Benjamin Franklin Myers and their children lived on a 105-acre farm that became Ridgelea Hills. Here, they sit on the front porch of their wood-frame house. "Back in those days when they couldn't afford it, they didn't buy paint," said Annabelle Royston-Linden. The porch was held up by logs. From left to right are Annie, Annabelle (age five) on her lap, George, Charles, Ben, and Shirley. (Annabelle Royston-Linden.)

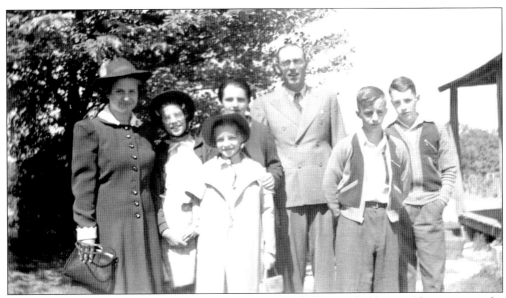

The Myers family lived in a six-room house on top of a hill. Ben's half-sister Alice came to the farm to live after her mother died. Alice was in her late teens. Ben's father died before his wife, so her half-brother took responsibility for Alice. Dressed in their best clothes, the family poses near their house. From left to right are Annie Myers, Shirley, Alice (back), Annabelle (front), Ben, George, and Charles. (Annabelle Royston-Linden.)

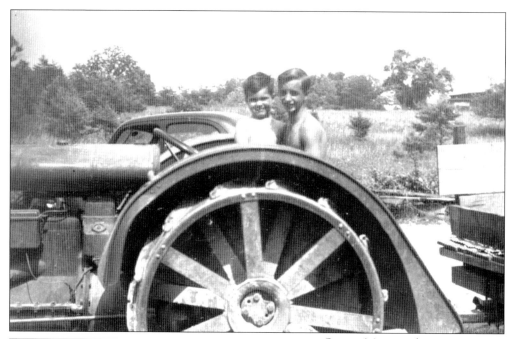

George Myers and cousin Georgie Stephens, five years old, visiting from California, play on a tractor. Nellie Stephens, sister of Ben Myers, lived in Coronado. Her husband worked at the famous Hotel del Coronado. On the farm, life was rustic. Annie Myers used the wood stove in her kitchen to cook meals. "We could usually look forward to her having fried chicken and delicious biscuits on Sundays," Annabelle said. (Annabelle Royston-Linden.)

Annabelle Myers (left), Georgie Stephens, and Shirley Myers pose on the cart used to haul things on the farm. Georgie had never seen farm equipment before his visit. "They flew from California," Annabelle said—a big deal in 1942 when many people considered air travel a luxury. "We spent hours taking hikes in the woods and playing in the fields." (Annabelle Royston-Linden.)

From left to right, Shirley Myers, Georgie Stephens, and Annabelle Myers play on the farm in 1942 when the Stephens visited from California. The Myers rented the farm from Leon Chatelain Sr., a Swiss-born Washington, DC, tailor who spent summers and occasional weekends at another house on the property. He told the Myers he bought the farm for $1,000 in 1930 and sold it for $10,000 in 1944, necessitating their move. (Annabelle Royston-Linden.)

Shirley (left) and Annabelle Myers aim snowballs on the farm around 1940. "The rent that we paid was for Dad to take care of the property, mend the fences and help Mr. Chatelain harvest the 10 long rows of Concord grapes in September so that he could make his wine that they enjoyed with their meals," Annabelle said. "My mom also made jelly and grape juice for the family." (Annabelle Royston-Linden.)

Shirley (left) and Annabelle Myers pose in dresses made by their mother. "We had 105 acres on that farm, and it was so much fun to go strolling," Annabelle said. Corn and alfalfa grew. "We had two cows that were used for milk for the family. A mule named Jack used to pull the plow to cultivate the fields." Six pigs were used for food, and about 30 chickens. (Annabelle Royston-Linden.)

The extended Myers family posed on the farm in 1942 when Charles graduated. From back left: Carson Click Myers, a sailor; Ben, and Isaac (nicknamed Ike). Front row: Ray, Ben's half-brother, in sailor hat, with Kenneth on his lap; Ike's sons, Ernest in the middle holding his son Joseph Patrick "Joe Pat" Myers; and Shannon Myers. Ray and Carson were both in the Navy. (Annabelle Royston-Linden.)

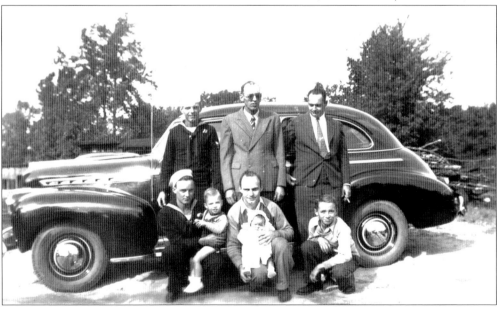

Charles E. Myers (left) and his father's half-sister Alice Myers graduated from Fairfax High School in 1944. Alice got a Pentagon job. "We had a Greyhound bus that went into DC every morning," Annabelle remembers. "It came from Knoxville, I think. . . . I still see that in my head." There was one bus daily in each direction, and rides were picked up and dropped off on the Little River Turnpike at Glenbrook Road. (Annabelle Royston-Linden.)

Shirley Myers poses in her new coat. "We went to Montgomery Ward's and bought that," Annabelle remembers. The family sometimes took in boarders—laborers at the Pentagon-- while on the farm. Annabelle said three West Virginians "came with their musical instruments, guitars, mandolins, violins, and a banjo." Every night, they played bluegrass music. (Annabelle Royston-Linden.)

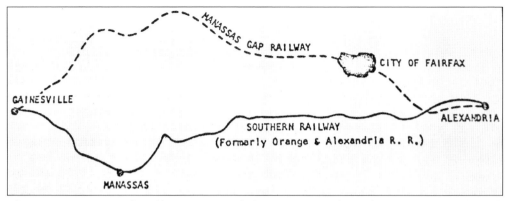

The Manassas Gap Railroad line was intended to run 35.5 miles and carry people and goods from Gainesville to Alexandria. Construction began in October 1854. The Civil War interrupted work, and the branch was never finished. The plat below of the Sunny Hills subdivision shows where the line was located. Remnants of the elevated bed (but no tracks) can be seen between Sunny Hills and Ridgelea Hills subdivision. Page Johnson II wrote: "The line entered the City of Fairfax from the present-day Mantua neighborhood, running parallel to Little River Turnpike (Main Street) . . . It passed south of the tank farm and continued through the Little River Hills, Fairview and Farrcroft neighborhoods into downtown Fairfax. Remnants of the railroad can be seen at Annandale Community Park. (Above, City of Fairfax Office of Planning; below, Dom and Donna Cipicchio.)

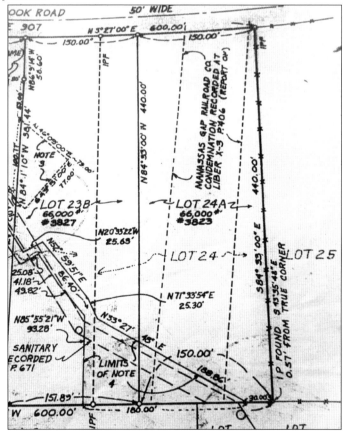

This one-and-a-half-story house at 3915 Glenbrook Road was built in 1945 by Ben and Annie Myers and still exists. They bought about 5 acres of land on both sides of Glenbrook Road. "It took a while for Dad to get the house built due to the shortage of building supplies because of the war," Annabelle said. (Photograph by the author.)

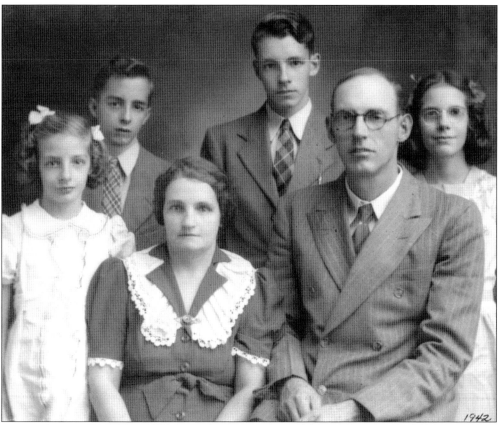

In 1942 the Myers family posed for a studio portrait. From left to right are Annabelle, 10; George, 17; Annie; Charles, 15; Ben; and Shirley, 12. Ben worked as a laborer on the Pentagon when it was built in the early 1940s. "Men came from surrounding areas to get jobs there. . . . My dad had bad eyesight and was not able to hold a good-paying job," Annabelle said. (Annabelle Royston-Linden.)

Charles Myers, pictured left, holds his son Stephen on his shoulder. Below, Stephen rides on a toy. The three-room chicken house the family lived in is at right. "I still remember when a moving company came in, jacked the building up, and moved it," Annabelle said. "Dad made the chicken house livable as best he could." The middle room was heated by a woodstove. "There was no room for my sister Shirley and I to sleep, so we went across Route 236 each evening to our mom's sister Ellen Dove's house" (where Providence Presbyterian Church is now). Mornings they walked to Preston Hunt's Fair Dale Grocery near Hunt Road to catch the school bus. (Both, courtesy of Annabelle Royston-Linden.)

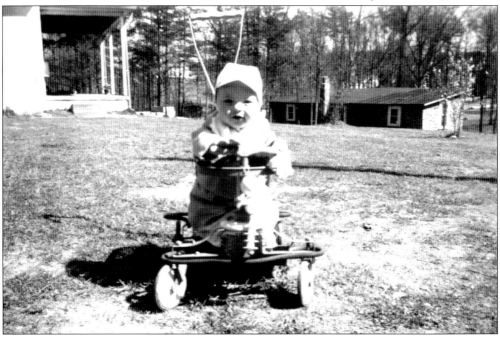

Shirley Myers (left) is shown holding Stephen Myers, her nephew, as they sit on the back stoop at 3915 Glenbrook Road, her parents' house. Laundry hangs in the background. About 15 years later, Ben and Annie later built another house but did not move far. It was at 3909 Glenbrook in 1959. (Annabelle Royston-Linden.)

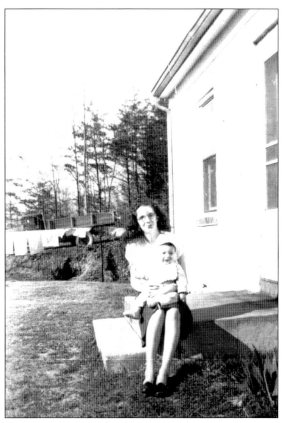

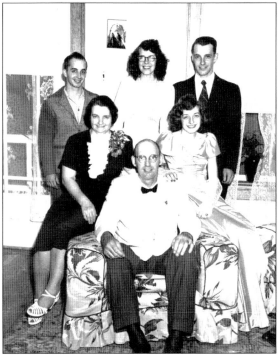

When Shirley Myers, back center, got married in 1950, the family posed in their living room. Ben is seated in front. Behind him, also seated, are Annie (left) and Annabelle (right). In the third row are Charles (left) and George. After living in the chicken house for a few years while the house was built, the family had a flush toilet for the first time. "I was 13 years old before we had a flush toilet," Annabelle remembers. (Annabelle Royston-Linden.)

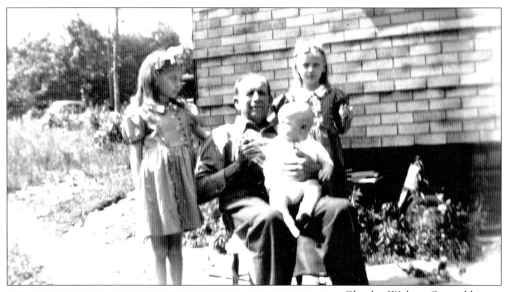

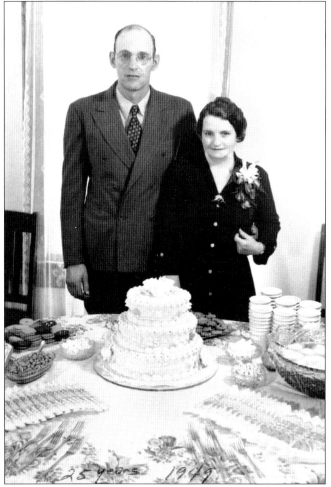

Charles Walters Sr. and his daughters Isabell (left) and Elizabeth (right) and his son Charles Jr. (on his lap) lived in the Myers' converted chicken house, shown here, after they moved. It was raised up from the ground on blocks and open at the bottom. "It wasn't fancy living," said Annabelle Royston-Linden. Walter Sr. put asbestos shingles on the outside of the house to make it warmer. (Elizabeth W. Smith.)

In 1949, Ben and Annie Myers celebrated their 25th wedding anniversary in their house at 3915 Glenbrook Road. Cake, cookies, and punch were served on elegant china and silverware. This photograph was taken by Dick Nachman of To You Home Photo Service of Vienna, Virginia. They celebrated their 50th anniversary in 1974 at Oakton Church of the Brethren. (Annabelle Royston-Linden.)

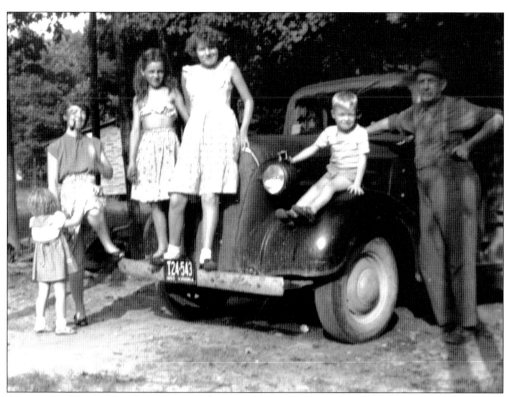

Above, the Walters family poses near the car of Charles Sr. around 1950. Naomi, with her foot on the bumper, sewed the same pattern of fabric to make her own skirt, the skirt and blouse on Isabell, standing left on the car fender, and Elizabeth. Evelyn Kay, left front, was born in the chicken house on October 31, 1947—the only child born in the house. Right, Charles Jr. poses near the house. Charles Sr. used to sell mountain laurels "to anybody who'd buy them," according to Annabelle Royston-Linden. "He went into neighborhoods and knocked on doors. I don't know where he got them." Mountain laurel (*Kalmia latifolia*) is an evergreen shrub native to Virginia. Its rose-pink or white-colored flowers bloom in Spring. The family later moved to Jefferson Village in Falls Church. (Both, courtesy of Elizabeth W. Smith.)

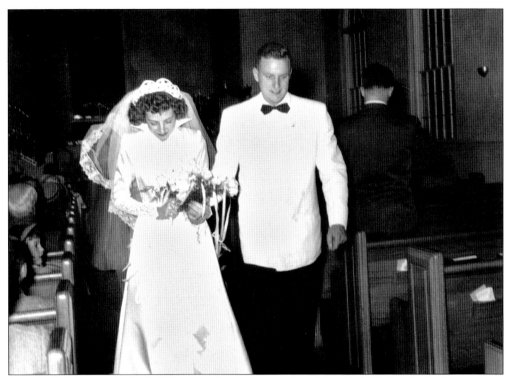

Annabelle Myers and Marshall Royston Jr. were married on May 19, 1951, "in the little sanctuary of Annandale Methodist Church." Annabelle's parents held the wedding reception at 3915 Glenbrook Road. Her mother made her wedding gown. "The sleeves on that dress were lace," Annabelle said. "We got married at a candlelight ceremony." Marshall died on June 7, 1983, at age 65, of cancer. (Annabelle Royston-Linden.)

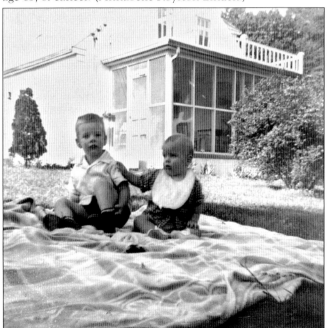

In 1952, Annabelle and Marshall Royston moved to 3916 Glenbrook Road with their son, Randy, six months old. "My father offered to build us a house," Annabelle said—across the road from his house. "We were able to purchase that home." Sons Richard and Russell were born in 1953 and 1958. In 1959, Ben and Annie Myers built a house at 3909 Glenbrook and moved again. (Annabelle Royston-Linden.)

Annabelle Royston-Linden poses in front of her Glenbrook Road house, essentially the same as when it was built in 1951. She was married to Victor Linden for 24 years until his death in 2015. She retired from the federal government in 1990 after 20 years to care for her mother, who had a stroke. Since 1999, Annabelle has been a member (and president several times) of the National Active and Retired Federal Employees, Northern Virginia chapter. "All in all, Glenbrook Road has been a great place to live and raise a family," she said. There have been changes: Her children attended Wakefield Forest Elementary School, not Mantua (built in 1961). The Skybrook subdivision that bordered Skyview Lane to the west arrived with the suburb. Olam Tikvah congregation on Glenbrook began around the same time. Some things do not change: a neighbor raises chickens. "I still love to hear the rooster crowing," Annabelle said, as she did on the farm that is now Ridgelea Hills. (Photograph by the author.)

Fairfax County property records show that the Dove family owned land that became some of the suburb, including sections along Barkley Drive and Glenbrook Road. The Petros Court House, shown here, incorporated an earlier house. Mantua Elementary School was built on Dove land bought in 1954 by the county from Payton Dove and his wife, Martha Dove. They had owned it since 1922. (Photograph by the author.)

Douglas N. Dove, brother of Payton Dove, and his wife, Louise Runyon Dove, owned about 17 acres, much of which became the Skybrook subdivision. They moved a small house from the end of Skyview Lane, Payton's land, to what became Petros Court. This intersection of Chantal Lane near Denise Lane and Petros Court once was a swimming hole for the Dove family. (Photograph by the author.)

Four

A SUBURB IS BORN

Americans have been expanding their cities outward by building suburban neighborhoods since the mid-19th century. From the end of World War I until 1945, suburbanization accelerated as more people owned automobiles. In the 1950s, the population of suburban areas increased by 19 million, compared to an increase of six million in the cities.

After World War II, the civilian federal government and the defense and military presence expanded in Washington, DC. Housing was needed for that workforce. Long-term, low-interest mortgage rates, including mortgage loans to veterans, put home ownership within reach for many Americans.

"Life in the postwar suburbs represented the fulfillment of the dream of home ownership and material well-being," wrote Linda Flint McClelland, a Mantua resident and coauthor with David L. Ames of the National Park Service's *Historic Residential Suburbs: Guidelines for Evaluation and Documentation for the National Register of Historic Places.*

Mantua is about 15 miles west of Washington on Arlington Boulevard, which is US Route 50, and about 15 miles from Washington on the Little River Turnpike, which is State Route 236—one of the oldest roads in the country. The location is within commuting distance of the Capitol. The subdivision known as Mantua Hills Section 1 began at Arlington Boulevard. The Sunny Hills section started off Little River Turnpike. Gradually roads were cut further east and west until many streets in the subdivisions met.

The neighborhood of Mantua was not developed by just one builder. The suburb sprouted piecemeal as tracts of land that had been parts of farms or vacant lots became available. One subdivision grew over decades into almost 20. Unlike some other post-war Northern Virginia neighborhoods, different house styles were encouraged. Some were one-of-a-kind creations, others standard blueprints with few customized features. Some had three bedrooms but were a modest size; others were more spacious with upscale features such as double garages and family recreation rooms.

Teardowns of houses began in the first decade of the 21st century, but many Mid-century Modern houses still exist, repaired and renovated. Here is a look at some of the first houses.

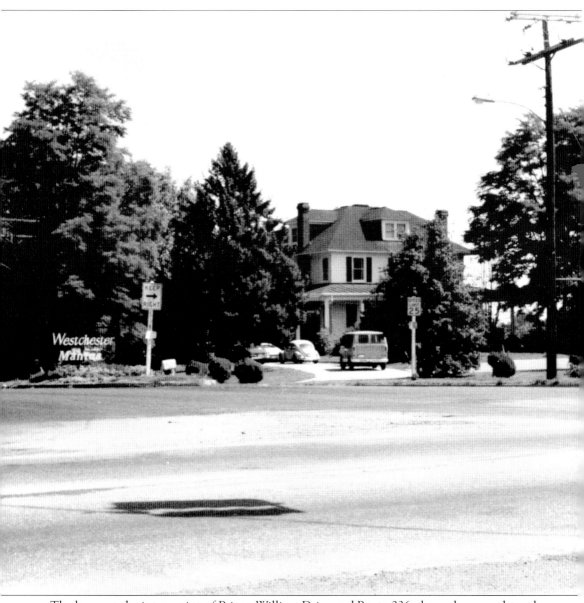

The house at the intersection of Prince William Drive and Route 236, shown here, predates the suburb. With the Chichester house in the north, a few houses existed in Mantua south in the 1940s. The earliest that survives is a 1945 1½-story house with a metal roof on Glenbrook Road south. Skyview Lane had some wood-frame houses. A brick Colonial built in 1946 on Mantua Drive was surrounded by contemporaries in 1971. The house above, at 9124 Little River Turnpike and Prince William Drive, was a residence and a shop in 1956. The 2½-story building with three single dormers then became a YMCA (Young Men's Christian Association), a national nonprofit "for youth development, healthy living, and social responsibility," according to its website. In 1996 Chabad Lubavitch of Northern Virginia, an orthodox Jewish organization, bought it. The two swimming pools and tennis court on 4.76 acres are a holdover from the Y. The religious group expanded the building. This photograph was taken when the Westchester subdivision in Mantua was new in 1977. (Karl Steinbach.)

This 1946 brick Colonial was surrounded by contemporary houses in 1971. It was built by Raymond A. Spagnolo, who started a construction business in the 1950s and later owned Yorktown Realty in Falls Church. "He was also especially talented in carpentry and woodworking," his obituary said. In retirement, he made fine furniture. The first child of immigrant parents, he married Marion Aldrich Wyman, a descendant of 1640 Massachusetts Bay Colony settlers. (Photograph by the author.)

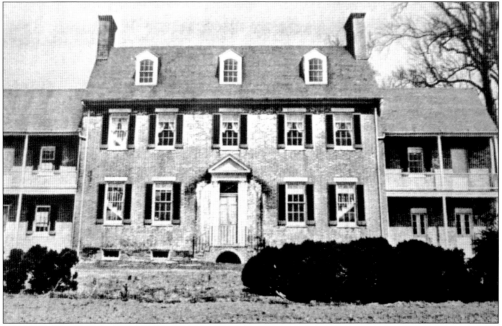

This 18th-century house named Mantua in Northumberland County, Virginia, may have provided inspiration for builders in the suburb. George Chichester's father, Col. Richard Chichester, the son of Richard Chichester and Ellen Ball, married Sarah McCarty, daughter of Capt. Daniel McCarty and Sinah Ball. Chichesters were related to Balls, who owned property near this Georgian brick mansion house built on the Coan River after 1785 and likely visited there. This image is from *Old Virginia Houses of the Northern Peninsulas.*

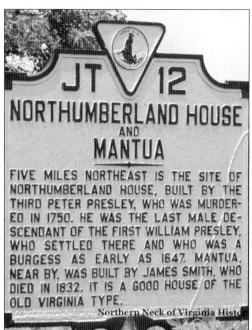

Northumberland House and Mantua Historical Marker No. JT-12, Claraville, Virginia, left, reads, "Five miles northeast is the site of Northumberland House, built by the third Peter Presley, who was murdered in 1750. He was the last male descendant of the first William Presley, who settled there and who was a burgess as early as 1647. Mantua, nearby, was built by James Smith, who died in 1832. It is a good house of the old Virginia type." William Presley had a 1,000-acre, 1657 land patent. The nearest town is Heathsville. Below is a side view of Mantua. Noted architectural photographer Frances Benjamin Johnston (1864–1952) documented early American buildings, including Mantua, for the Carnegie Survey of the South. The Carnegie survey contains more than 7,100 images of about 1,700 structures and places. (Left, Northern Neck of Virginia Historical Society; below, Prints and Photographs Division, LOC.)

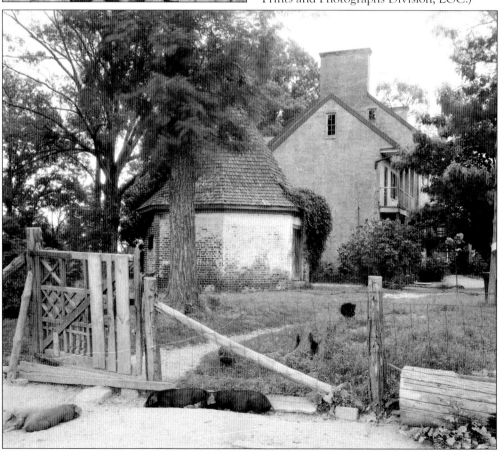

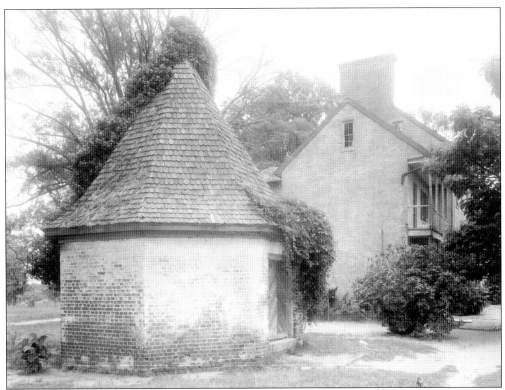

Mantua was situated on 28 acres. It had a six-sided brick smokehouse, above at left, with a steep-pitched, almost Oriental-influence roof. It would have been used to process meats for the household, but because of its large size might have been a commercial operation. The porch, here at right, was photographed in 1935 as part of the Carnegie Survey of the South. It was at the back of the house, according to the book *Old Virginia Houses of the Northern Peninsulas*, printed in 1992. Rural and suburban sites in Virginia, Maryland, North and South Carolina, Georgia, Alabama, Louisiana, Florida, West Virginia, and Mississippi were in the survey. Images of churches, houses, outbuildings, plantations, mansions, and mills were included, both grand and vernacular structures. (Both, Prints and Photographs Division, LOC.)

The stairs in Mantua in Northumberland County, shown here, are similar to those constructed in some of the Mantua suburb houses. The new Colonial houses also had other similarities: a medium pitch, side-gable roof, and double-hung windows, but not always a center-hall foyer. The entrance was accented with columns, pilasters, pediments, and sometimes a covered porch and entry columns. But the shutters were decorative, not functional. (Prints and Photographs Division, LOC.)

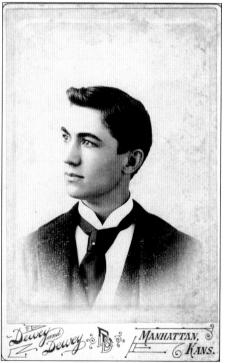

LeRoy Eakin Sr., called "Daddy Roy" by the family, developed the Mantua suburb. Born in Marion, Ohio, in 1875, he went to school until eighth grade. At age 17, his father sent him to Manhattan, Kansas, to work in his uncle's Spot Cash store, a wholesale farm-supply business that sold products at a discount for those who paid cash. He eventually owned Spot Cash, sold it, and went east around 1925. (The Eakin family.)

Daddy Roy, left, founded Eakin Properties in 1932, focusing on commercial properties, including in Falls Church-Seven Corners. In 1935, he developed Hillwood and later Sleepy Hollow. By 1939, the company had about 100 acres. The company paid low salaries, so LeRoy sold land at highly discounted prices to employees—which he paid $50 per acre for in the 1930s. He acquired about 1,500 acres. (The Eakin family.)

Pres. Dwight D. Eisenhower (left) and LeRoy Eakin Sr. relax outdoors. This photograph may have been taken at Camp David, the presidential retreat Eisenhower named after his son and grandson. Eisenhower built a practice golf facility at Camp David while he was president, and LeRoy was an avid golfer. The Eisenhower and Eakin families knew each other from Kansas. (The Eakin family.)

Milton S. Eisenhower (left), Dwight D. Eisenhower's brother, stands with his father-in-law, LeRoy Eakin Sr., on a dock after fishing. Milton and Dwight fished and golfed with Eakin. The Eisenhowers had encouraged Eakin to move from Kansas, where the families knew each other. In 1951, Eakin donated 15 acres for Fairfax County's first public park. In 1966, he donated $50,000 to a trust fund to maintain and develop Eakin Park. (The Eakin family.)

Right, LeRoy Eakin Sr. chats with Charlotte Montgomery, the first secretary, bookkeeper, and office manager for Eakin Properties, where she worked for over 60 years. He donated 140 acres total for Fairfax County parks and more than $150,000 in cash. A matching arrangement with the park authority resulted in the acquisition of 225 acres along Accotink Creek. It started with a 15-acre Mantua donation. (The Eakin family.)

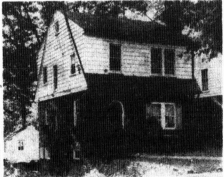

Developers built neighborhoods with restrictive covenants in the early 20th century to shape
their demographics. In the bottom right corner, an ad for three-bedroom, two-bath ramblers on
November 10, 1951, in the *Evening Star*, a Washington, DC, newspaper, showcased "New and
Restricted Mantua." The deed of dedication filed for Mantua Section One on January 4, 1950,
in county Deed Book 734, page 526 contained covenants, rules that governed setbacks from
the road and lot lines, and what could not be constructed on the land. The Federal Housing
Administration, created in 1934, offered favorable-term loans to neighborhoods with covenants.
Forbidden in Mantua were "tourist homes, guest houses, nursery schools or other similar home
businesses" and trailers, tents, shacks, barns, garage, or outbuildings. One covenant stated, "No
person of any race other than the Caucasian race shall use or occupy any building or any lot,
except that this covenant shall not prevent occupancy by domestic servants of a different race
domiciled with an owner or tenant." The Fair Housing Act of 1968 made racially restrictive
language illegal. (LOC.)

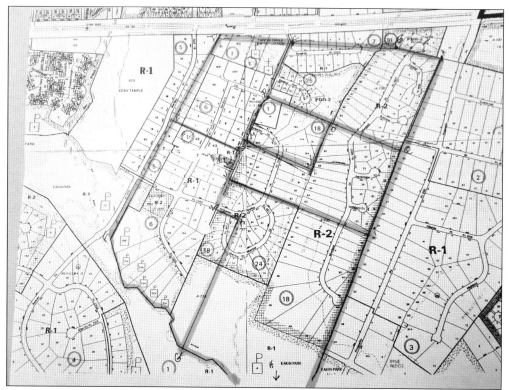

Mantua developed in sections from 1945 (Glenbrook Road) to 2020. This 1978 real property identification map shows the boundaries of some subdivisions on former Chichester land. Route 50 is at the top. Some of the land is also in Pine Ridge. The subdivision Woodson Reserve is top left, where the Kena Shriners once were located. When he proposed Woodson Reserve, the developer John Sekas offered 13 acres to Fairfax County for parks. (Fairfax County.)

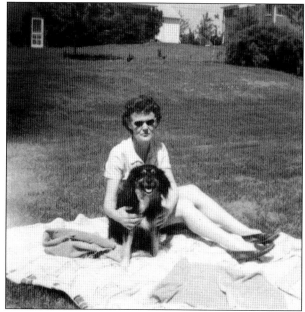

Ruth Condon (left) and her husband, Jack, bought a Mantua rambler in 1964. They were typical new suburb residents: She worked for the federal government, he served in the military, and they had a child. Most wanted three- and four-bedroom houses and good roads to commute into Washington. Until she died in 2019 at age 102, she walked the streets daily, even with her walker and caregiver. (Carl Condon.)

70

Mantua did not have "cookie-cutter" houses, Ruth Condon said in a *Mantua Newsletter* in 2017. They had hardwood floors, and one could choose bathroom colors: sky blue, dandelion yellow, soft pink, peach, and aqua. Mantua residents knew her Ponce Place rambler, seen here, as the one with a train track on the front lawn year-round since the 1980s, courtesy of her son Carl. (Author's collection.)

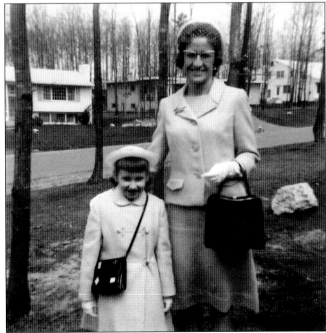

Jane Buchanan and her daughter Cindy pose on Easter 1964 in their yard at 9209 Saint Marks Place. Three house styles—split foyer, flat-roof contemporary, and split level—were across the street. Cindy remembers when Thompson dairy delivered milk to an aluminum box on their back porch. The concrete gutter was built by inmates: "The sheriff sat down . . . with a shotgun across his lap and watched the prisoners work." (Cindy and Jane Buchanan.)

The split foyer, shown here, is sometimes called a raised ranch. The style was built in Mantua Hills starting in 1961. Douglas Rosenbaum and Sigmund Goldblatt's Dorado Corporation, which bought 107 lots, almost 90 acres, sold this one on Saint Marks Place. It offered two levels of living space. The split supposedly divided public and private spaces. Most came with a one or two-car garage. Living areas featured a "picture" window to allow natural light inside. Chuck Sanders paid $36,000 for a brick Phoenix Builders' split foyer at 9102 Southwick Street in 1963. Prince William Drive was unpaved between Lido and Route 236. His house with two additions sold in 2018 for $749,000. In 1968, Goldblatt, who developed Mantua Hills, and others were tried for conspiring to bribe members of the Fairfax County Board of Supervisors to vote for rezoning 83.4 acres in Fairfax County (not in Mantua) in which the partnership was interested. Two supervisors were convicted of bribery in federal court. (Photograph by the author.)

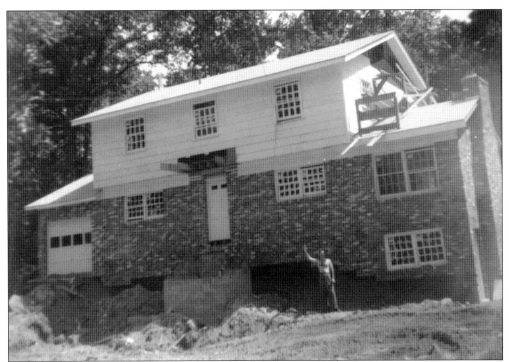

William M. "Bill" Lockwood was one of the first residents of Section One of Mantua Hills. Here, the exuberant resident-to-be waves from the construction site at Lot 12 on Hamilton Drive. Lockwood, a Marine Corps veteran of World War II, worked for the federal government as a planner, program analyst, and supervisory real estate officer. He later became a realtor and sold many Mantua houses. Below, Bill and Kaye Lockwood, shown here with their daughters Kathleen (front) and Shery, bought 1819 Hamilton Drive in 1961. In 1965, Fairfax County renumbered addresses, and it became 9113 Hamilton Drive. The Colonial style incorporated fake shutters and architectural details such as door pediments. (Both, Kathleen Lockwood Greene.)

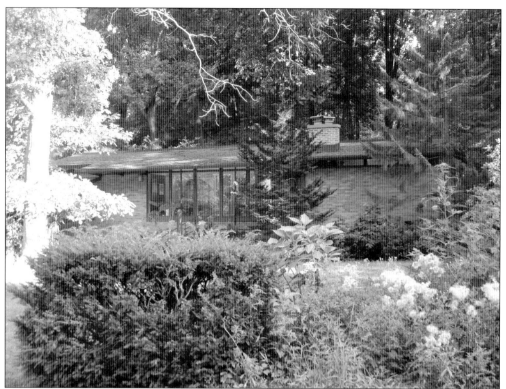

"Have you seen the solar house?" That is how the one above was advertised in 1957 in the *Washington Post*. It had four master bedrooms and a 40-feet balcony along the back, a cathedral ceiling, some glass walls, and "indirect lighting." The price was $35,500. The house below was on the same street, as were long, low ramblers and imposing Colonials. Most lots were an acre and more, with many backyards on parkland (which eventually grew to 74 acres). Crossing the one-lane Accotink Bridge on Barkley Drive led homebuyers to a section of Glenbrook Road near the parkland that LeRoy Eakin Sr. had donated in 1951. It also was a place for builders to try new models, such as these contemporaries. The Accotink Creek bridge on Barkley Drive, the access road to get to these houses, was not widened until 1964. (Both photographs by the author.)

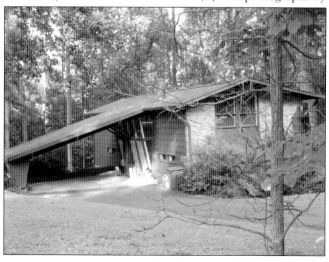

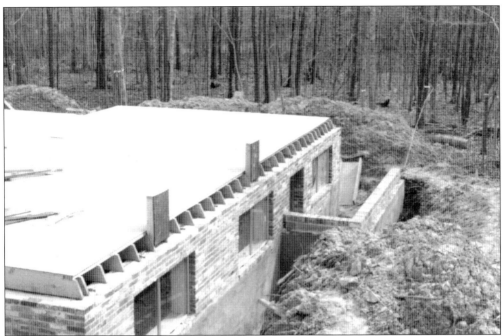

Karl H. Steinbach and his wife, Doca, moved to their contemporary by Phoenix Builders on Coronado Terrace in August 1963, four years after they immigrated from Konstanz, Germany. The roof, shown here before, was a mixture of tar with a gravel overlay, not the traditional shingle. The smaller houses of the model had three bedrooms and a single carport, seen below; the larger houses had four bedrooms and a double carport (one sold in 2020 for $956,500). The Steinbachs named their home "Castleacre" after their temporary residence in London, although, in Mantua, it was on half an acre. Karl was a researcher in radar technology at Fort Belvoir. He later directed the US Army's European Research Office in London. (Both, Karl and Boris Steinbach.)

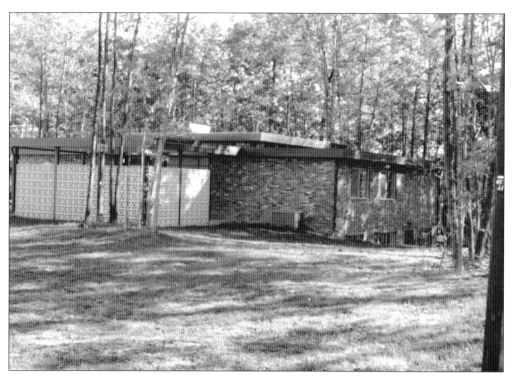

Phoenix Builders' contemporary design, seen here, may have been inspired by Frank Lloyd Wright—or so residents of the suburb claimed. It had clerestory windows to allow light to enter rooms but still ensure privacy, and a brick-wall fireplace—or several, including in the kitchen. The open floor plan encouraged movement around the living space but allowed privacy in bedrooms, a separate area of the house. (Karl and Boris Steinbach.)

German immigrants Edwin and Ilse Bornemann bought a Ken Freeman split foyer at 3610 Prince William Drive in 1964. Freeman, a New York clothing designer, moved to Maryland in the 1960s and became a developer. Left, Ilse and her children enjoy their patio. The Bornemanns had met the Steinbachs as neighbors at Hamlet West Apartments in Alexandria. (Ilse Bornemann.)

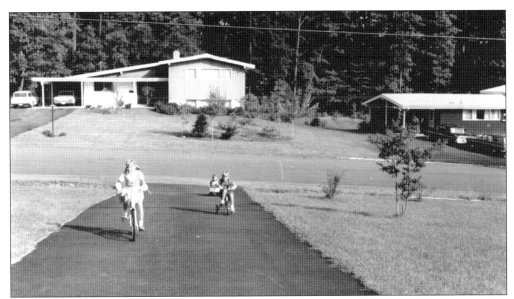

The Bornemann children, seen here, ride bicycles in their driveway. Houses like these by Ken Freeman line stretches of Mantua Hills along Prince William Drive. His designs also are found in Bethesda, Maryland's Bradley Park subdivision. He disliked Washington-area Colonial houses. He espoused clean lines, an interior that flowed seamlessly, and windows without small panes. (Ilse Bornemann.)

Merlin "Mac" McLaughlin, here with his children, bought a first-of-its-kind four-level split, $33,000 in 1964. McLaughlin was a land surveyor who prepared site and grading plans for Bill Goldstein of Norbar Construction, and other small builders bought lots from Sigmund Goldblatt. McLaughlin said his purchase of 3311 Mill Springs Drive "was a very unusual transaction." He and Goldstein "shook hands . . . we never drew up a contract." (Kathy McLaughlin Roberts.)

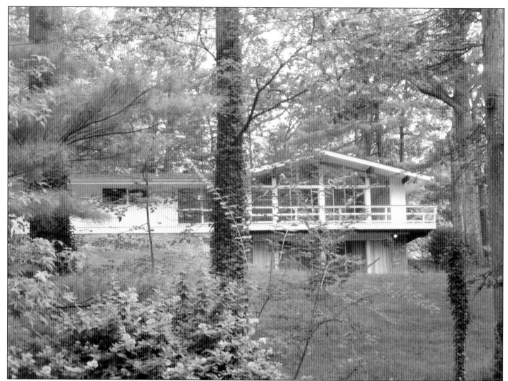

Taking advantage of its lofty location, Col. Howard C. Junkermann's 1959 house at 3501 Barkley had six Thermopane insulating windows creating what the architect called a "window wall" to a wood balcony perched off the side. Custom wood cabinets in the kitchen (with a pink wall double oven) were plain. "The original owner actually went to Alaska to pick out the timber (redwood beams) that he shipped back," owner Sheri Pitigala said. Junkermann, a World War II fighter pilot who retired from the US Air Force, had several patents, including one for a tree pruner and hedge trimmer attached to a backpack. Perhaps his steep hillside house inspired him to find an easier way to trim branches. A steep drainage ditch at the bottom of the hill discouraged the use of the lawn. (Above, photograph by the author; below, Sheri Pitigala.)

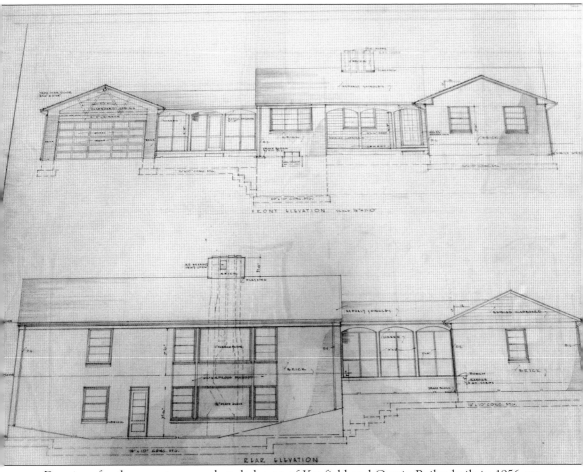

Drawings for the one-story ranch-style house of Kenfield and Grecia Bailey built in 1956 are part of a collection of noted architect Donald Hudson Drayer's works in the Library of Congress. On Lot 57, Section 3 (3521 Barkley Drive), it had 140 feet of street frontage with a circular blue stone driveway. Drayer's blueprint for the brick and masonry dwelling dated February 3, 1955, shows a ground floor with a recreation room and "plate glass" window spanning more than 10 feet across and 4.4 feet high to provide natural light, a hobby room, laundry room, workroom, darkroom, third full bathroom, and a separate room for oil tank for heating. Drayer (1909–1973) also designed the Watergate Apartment Hotel in Washington, office buildings and shopping centers, and many houses, including one for Pauline and Sen. Albert Gore Sr. in Washington. (Prints and Photographs Division, LOC.)

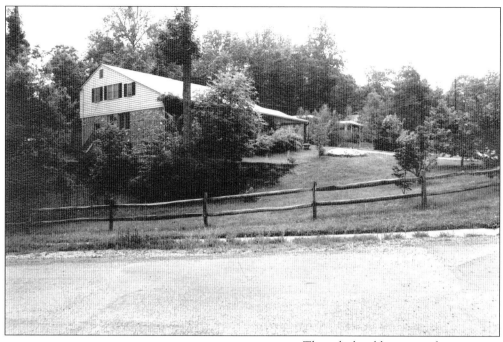

The split-level house on the corner of Saint Marks Place and Alba Place (above) was bought by Willis Schaefer in 1961 for $47,950 on a half-acre. It was the most expensive on the block and one of the largest models: four bedrooms, four bathrooms, plus two bedrooms in the 1,800-square-foot basement—and a two-car garage. In 2020, a similar house sold for $930,000. It had a 330-square-feet indoor pool and a second-floor balcony overlooking the living area. Elizabeth Schaefer (later Wassell), left holding a rabbit, remembers that the lot next door was "swampy with a pond." The builder made an offer to her parents to buy it for $5,000. They did not, so children "played with frogs in the pond." Eventually, the lot got sold, and a house was built. Children continued to shimmy down wide openings of the stormwater system and play there. (Both, Elizabeth Wassell.)

Five

A COMMUNITY FORMS

When Mantua the suburb began after World War II, residents had much in common. Demographically, they were white and middle class, with many holding professional jobs in the federal government or military ranks. Physicians and nurses moved to Mantua after Fairfax Hospital opened in 1961. Many women did not work outside the home. They took care of families and were active in community groups. They formed clubs for gardening, books, bridge, cooking, bowling, and other interests.

Civic engagement was part of the new community. The first citizens' association was formed by residents in the older subdivisions of Mantua. Fifty-seven member households joined in April 1957 to establish the Constitution of the Mantua/Langhorne Acres/Fairfax Forest/Oak Springs Village Citizens' Association. Its purposes were stated as "to encourage and foster among its members a spirit of mutual cooperation and assistance; to promote among its members a sense of civic responsibility; and to be the medium whereby the community may act collectively on civic matters of mutual interest to its members." Membership was $5 per year. By November 1959, the group called itself the Mantua Citizens' Association (MCA) and had 75 member households. In 1981, there were 1,132.

The women's club formed in 1957 and expanded by 1980 to include matinee theater, daytime bridge, needlecraft, and gourmet cooking groups. Its scholarship committee raised and awarded funds for promising students to use toward college. One committee focused on ways to help the less fortunate, Fairfax nursing home residents, the youth "detention home," and mental health projects.

In 1981, the 20-year-old Mantua Babysitters Co-op had two groups "geared to weekday, daytime use to give mothers of young children free time for appointments and other activities," the MCA newsletter said.

The MCA published its first newsletter in November 1963. It was a key form of communication before the Internet. By the 1990s, the association had a website to publicize activities such as the annual National Night Out, a way to foster law enforcement and community relations and promote the Neighborhood Watch crime prevention program. More than 1,000 neighbors participated in 2019. Here is a look at some community activities.

Before yard sales became an American staple, residents of the suburb held indoor sales of items that could still be useful to others: clothes and toys that their children had outgrown, playpens, knickknacks, and household things. This early 1960s photograph shows a shopper in the family room of Jane and George Buchanan's house at 9209 Saint Marks Place. (Jane and Cindy Buchanan.)

Pat Troutman (left) and George Buchanan compare scores at the January 1969 Mantua Mixed Bowling tournament in Annandale. Troutman was the first Mantua Citizens' Association newsletter editor. "We edited, cut and pasted on the living room floor, had it printed and delivered by volunteers," she said. One 1964 four-page issue listed 32 reporters. A holiday potluck was news, as was a swimming pool reminder that "women must wear bathing caps." (Jane and Cindy Buchanan.)

Phyllis Bushey (right) reacts to her gutterball at a bowling tournament. The sport was so popular that a Thursday morning Merry Makers league competed with weekend leagues. Kaye Lockwood, seen below to the left, and George Buchanan kept score. Early newsletters published news about sports, activities, and residents. In 1976, heart surgeon Dr. Edward LeFrak "is the reason why thousands of people go to this previously obscure hospital (Inova Fairfax) in search of better health," editor Georgeann Kessler wrote in her "Bits & Pieces" column, a mix of gossip and helpful notices. In 1976, speeders were reported to the police by citizens; license numbers were printed. Classified ads sometimes ran four pages long. One 1976 issue had for sale a silver fox jacket, a 1966 Mustang, a chainsaw, and a rifle. (Both, Jane and Cindy Buchanan.)

George Buchanan (left) was pivotal in starting the Mantua charter bus service in 1970 and running it for decades. Mantuans commuted into Washington for work. In 1970, a total of 75 residents went to their jobs for $1 per ride. The county board of supervisors provided a subsidy in 1976. The bus was a model of what could be done by volunteers at the neighborhood level. In 1980, there were 200 regular passengers and two buses with 13 stops in Mantua and surrounding neighborhoods. After Dunn Loring and Vienna Metro stations opened in the 1980s, ridership decreased, but van service existed until about 2000. Below, in the 1960s, the idea of ride-sharing to work was new in the Washington area, but Mantua residents embraced it. From left to right, Doug Scott, Ben Fisher, and Amnon Golan get ready to commute into their jobs in Washington. (Both, FCPLPA/Connection Newspapers.)

Bill Lockwood, shown above with granddaughter Erin, lived civic life to the fullest. He was president of the Mantua Citizens' Association and helped start the private-member Mantua Hills Swimming Association (now Mantua Swim and Tennis Club) in 1963. He was president of the Luther Jackson Intermediate School Parents and Teachers Association and the Woodson High School Students, Parents and Teachers Association; his daughters attended the schools. He was active at Saint Ambrose Catholic Church. He was appointed to the Fairfax County Planning Commission and served 13 years there before running for Providence District supervisor in 1983. He did not win but continued to be active in civic affairs until the 2000s. In 2016, the Mantua community placed a memorial bench in his honor at the swim clubhouse. Until 2019, four generations of Lockwoods lived in the Hamilton Drive house he built. (Both, Kathleen Lockwood Greene.)

The Mantua Women's Club began in 1957 and ended around 2010. A section of the Fairfax County Park Authority's Mantua park along Accotink Creek is named for Sally Ormsby (above right), a club president and longtime activist with state and local groups. Ormsby was a three-term board representative to the Northern Virginia Soil and Water Conservation District. At left, giving her a commendation, is former Providence District supervisor Linda Q. Smyth. (Martha Lamb and the Mantua Women's Club.)

Fran Kieffer, shown left with her husband, Jerry, also was an activist who belonged to the League of Women Voters and managed the national youth voter registration project. She conducted local and national education workshops on air quality and hazardous waste. Like Ormsby, she was a member of the Mantua Citizens' Association tank farm committee in the 1990s. (Martha Lamb and the Mantua Women's Club.)

The Mantua Women's Club created this patriotic bicentennial quilt in 1976. If one did not sew, no problem—there were other activities. John and Elaine Bogart (right) organized musical events. Eda R. Pickholtz, a resident since 1972, said, "Elaine Bogart would introduce each concert in an evening gown. . . . You would buy a membership for about $40 for four concerts, usually on a Sunday afternoon. They were first held at Fairfax High School and many years later at Oakton High School. At one time, the membership was up to 1,200. We had duo pianists, Broadway shows, orchestras, foreign dancers. . . . After many of the concerts, she and John would invite the artists over to their house on Hamilton Drive for a potluck and to reward the sellers [of tickets to events]. She often rewarded us with a luncheon at P.J. Skidoo's." (Above, Cindy and Jane Buchanan; right, Martha Lamb and the Mantua Women's Club.)

The Mantua Women's Club provided musical entertainment at many of their functions as well as at community places, including churches and nursing homes. The Virginian, a continuing-care retirement and health care facility, is located near Accotink Creek. Besides singing, the group always dressed up and had a theme. Above, for a Veterans' Day songfest, they donned Army caps; many active military members and veterans have called Mantua home since the suburb began. The group also dressed as cowgirls, below, as Mrs. Claus for Christmas, as flapper girls, and as anything else their imagination concocted. Along with having fun, they always had a purpose: raising funds for various social and nonprofit causes. (Both, Martha Lamb and the Mantua Women's Club.)

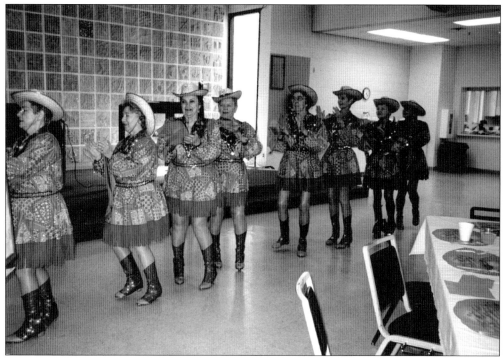

Mantua attracted people interested in world affairs. From 1960 to 2004, Thelma Kouzes (right) hosted 174 international students from 34 countries at 3524 Barkley Drive, her rambler built in 1957. The daughter of Danish immigrants, she moved from Iowa in 1938 to work for President Roosevelt's administration. Her husband, Thomas, became a deputy assistant secretary of the labor department. Thelma said in an interview shortly before her 100th birthday that her attendance at a segregated religious service was a culture shock. It prompted her to march with Dr. Martin Luther King Jr. in 1963 in Washington. She became an activist for Virginia public school integration. Her volunteer activities included UNICEF, American Mothers, Inc., and the women's club. She died in 2017. Below, a women's club fashion show at a dress shop where the members were the models. (Both, Martha Lamb and the Mantua Women's Club.)

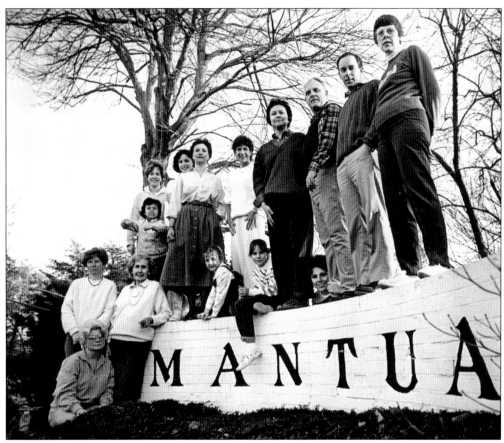

The garden club maintained community entrances. Standing near the Arlington Boulevard entrance sign are, from left to right, Allison Maltby, Erin Greene, Kaye Lockwood, Christy Maltby, Megan Maltby, Mary Delgado, Rosa Maria Del Agula, Sandi McArter, Cheryl and Steve Cranford, Miriam and Charles Bechtel, Kathleen Lockwood Greene, Charlotte Bechtel, and Sally Ormsby. Norm Neiss, in the photograph at left, for decades was active in the Mantua Citizens' Association (MCA) as president, Architectural Review Committee chair, and Neighborhood Watch coordinator. In 1997, MCA "block captains" were directed to gather personal information about residents. MCA dues included a community directory. MCA newsletter classifieds in September 1980 included: a 32-foot heavy-duty wood Sears extension ladder, $85; a piano in good condition, $450; a girl's black velvet hard hat for horse riding, size 6.75, in excellent condition, $8; exercise bench "never used," $25. (Both, FCPLPA/Connection Newspapers.)

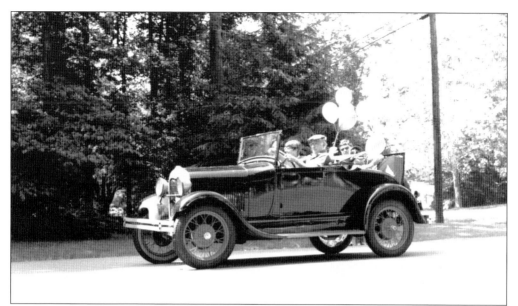

The annual MCA-sponsored parade and picnic began in 1978 on Memorial Day to boost community spirit and foster a small-town atmosphere on the doorstep of the nation's capital. Residents of all ages marched, played musical instruments, or rode in decorated or vintage cars like the one above to promote their organizations and causes. Children were encouraged to ride bikes. Any resident could participate. (Gene R. Shuman)

The parade even had a printed flyer by 1990 (right) and themed floats and sponsors: Grand Marshal's float, from Judy Wonus, Mount Vernon Realty; Alba Place, "The Liberty Bell," sponsored by Carolyn Wilson and Nancy Gunn of Long and Foster Realtors; "The Berlin Wall" from Colesbury Place, PineRidge Texaco station; "The Sweetest Deal in Town," Gayle Dudley of Shannon and Luchs; and "Freedom From School," by Cub Scout Pack 1533. (Kathleen Lockwood Greene.)

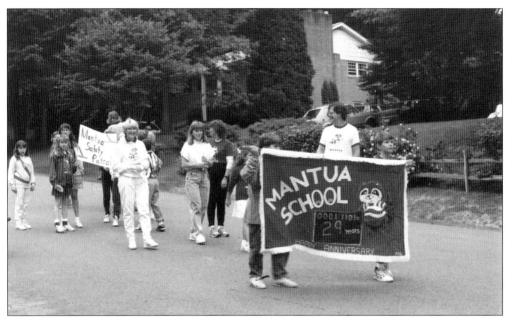

In 1990, students and parents carried the Mantua Elementary School banner in the parade. One of the parade highlights every year included entertainment by members of Kena Shriners International, who performed complicated maneuvers in small cars that delighted viewers. The fraternal organization based on Masonic principles that does charitable works to support Shriners Hospitals for Children had headquarters in Mantua from 1976 until 2018, when they moved to Manassas. Woodson Reserve houses were built on part of the 26 acres they sold to developer John Sekas, who donated almost 13 acres in the floodplain to Fairfax County to extend the park system. (Above, Kathleen Lockwood Greene; below, FCPLPA/Connection Newspapers.)

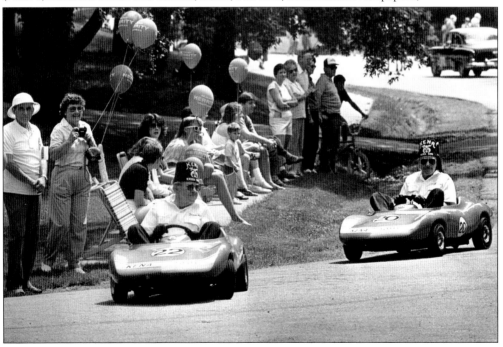

Citizens association president Bill Lockwood rides in the parade. Mantua has been home for many politicians. Among them: Emilie F. Miller represented the 34th Virginia Senate District 1988–1992 and championed women's rights, including admission to the Virginia Military Institute; Providence District supervisor (2019–) Dalia Palchik, who served on the Fairfax County School Board; Gary L. Bauer, who served in President Reagan's administration and was a Republican candidate for president in 2000; and Republican Stephen E. Gordy, who was in the Virginia House of Delegates 1982–1987. Rep. Gerald E. "Gerry" Connolly has represented Virginia's 11th District since 2008 after 14 years on the Fairfax County Board of Supervisors, including five as chair. His district includes Fairfax County and Prince William County, home to more than 50,000 federal workers. As the newsletter below attests, he started his political career in Mantua. (Above, Kathleen Lockwood Greene.)

MANTUA NEWSLETTER

Vol. XXVI, Issue 9 Mantua Citizens' Association — Gerry Connolly, President May, 1991

LETTER FROM THE PRESIDENT

Dear Neighbor:

This past month has been one of the loveliest Aprils in recent memory. Mantua is awash in dogwoods, azaleas, and the scents of spring. It has also been a time of concern in our community with

MEMORIAL DAY FESTIVAL

Plans are being finalized for the Memorial Day Festival which is to be held Saturday, May 25, 1991, (rain date is Monday, May 27th), on the grounds of Mantua Elementary School. The following events are being scheduled:

Parkland has always defined the Mantua area. A ceremony was held at the Mantua section of Eakin Park, at Glenbrook Road and Hamilton Drive, on September 16, 2000, to celebrate the 50th anniversary of LeRoy Eakin Sr.'s donation of 15 acres for the first park in Fairfax County's park system. From left to right are Terry Eakin, Kevin Eakin, LeRoy Eakin Jr., Richard Eakin, Laura Eakin Erlacher, and John R. Eakin Jr. The Elly Doyle Park Service Award was established in 1989 to honor park volunteers. LeRoy Jr. and his family were honored that year. The trees and park-like atmosphere in Mantua attract nature lovers, as does the Gerry Connolly Cross-County Trail (CCT), a 40-mile popular recreational place for runners, bicyclists, and walkers named after a Mantua resident and congressman. To the left, Representative Connolly dedicates the trail in 2014. (Both, Fairfax County Park Authority.)

Six

THE "TANK FARM"

On a September day in 1990, a Mantua resident noticed a sheen of oil glistening on the surface of Crook Branch, a tributary of the Accotink Creek that meanders past the elementary school and on through the neighborhood.

That discovery led to years of neighborhood alarm after the source was identified: an underground leak from a storage tank at a petroleum holding facility built on the edge of Mantua in the 1960s as the suburb was developing.

The ensuing drama raised concern about the personal health and safety of residents and the impact on their property values. Neighborhood representatives locked horns with the deep-pocketed oil concern that operated the "tank farm," as it was dubbed.

For years, the quiet residential neighborhood was thrust into the middle of the nation's increasing concern for the environment. A decade before, the nation's "Superfund" program—the Comprehensive Environmental Response, Compensation, and Liability Act of 1980—was passed, a law designed to investigate and clean up sites contaminated with hazardous substances. The US Environmental Protection Agency (EPA) administered it. At the request of the Virginia Water Control Board, in June 1991, the EPA directed the oil company to investigate and contain the spill. EPA oversaw remediation efforts that continued for decades.

Taken from official records and contemporary accounts, this is the story of Mantua's tank farm crisis.

Even before it began operation in 1965, citizens expressed opposition to the construction of a facility close to residential areas and schools because of safety concerns. The Colonial pipeline would carry oil to companies at the facility to refine it, then transport it by tanker truck. In May 1963, when the "tank farm" was proposed over 114 acres of a 230-acre tract, the Mantua Citizens' Association published *The Oil Dump Coloring Book*, above. It can be found in the Fairfax County Public Library Virginia Room Archives, Rare Books. The county's newest high school, Wilbur Tucker Woodson, about a half-mile south of the facility, had opened in September 1962 with an enrollment of 1,800; by 1965, it reached 3,300. Trucks would use from Pickett Road was the Little River Turnpike (Route 236), which linked with the new Capital Beltway (Interstate 495). The intersection of Route 236 and Pickett Road would carry both trucks and school buses. (Both, author's collection.)

The Mantua Citizens' Association book pictured "Big Oil" as Goliath defending the tank farm and citizens as David, who slays the giant. In the map at right are subdivisions surrounding the tank farm. Mantua subdivisions are on the right. Mantua School is also listed. Woodson High is to the south. Some City of Fairfax neighborhoods also opposed a tank farm. (Author's collection.)

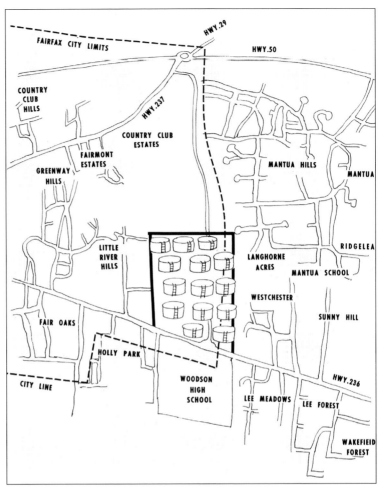

THIS IS A DOLLAR.
IT IS A TAX DOLLAR.
SEE THOSE SPOTS; THEY ARE OIL.
THEY MAKE A DOLLAR VERY SLIPPERY.
COLOR THIS.... RUN, SPOT, RUN.

In 1963, two lawsuits filed in Fairfax County Circuit Court attempted to declare the city permit approval illegal. Mantua requested a 50¢ donation for the 18-page book to fund an appeal of the 1962 city decision to allow the facility. By August 1963, other neighborhoods joined the battle, including Pine Ridge, Chestnut Hills, Mill Creek Park, Lee Forest, Westchester, Wakefield Forest, and Holmes Run Acres. The Fairfax County Public School Board and Fairfax County also opposed the facility. It opened in 1964. (Author's collection.)

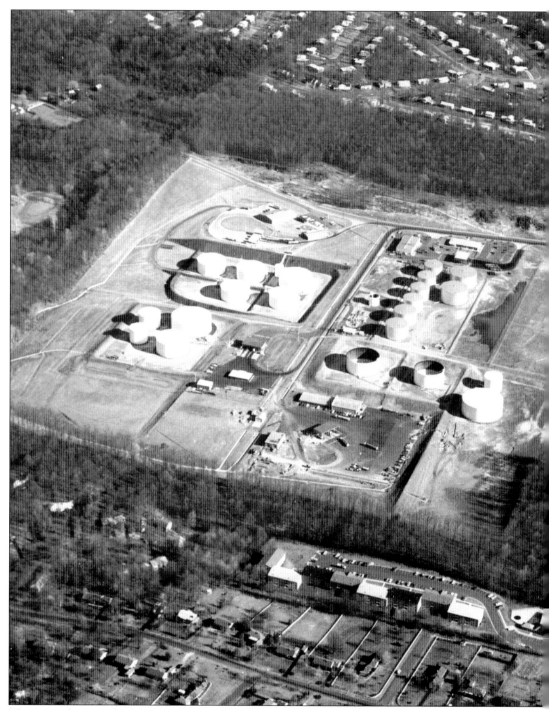

This view photographed in 1969 by Blue Ridge Aerial Surveys for the Fairfax County Economic Development Authority shows the growth of the oil facility approved by the City of Fairfax on Pickett Road in the early 1960s, when the Mantua suburb was beginning. This photograph appeared in the Fairfax Connection, a weekly publication that covered local government and community meetings on the facility before it was built and after the oil spill in 1990. The intersection of

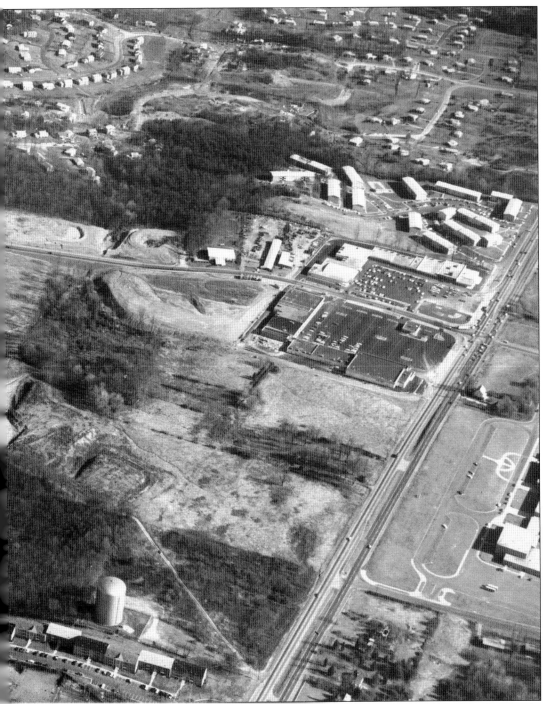

Pickett Road and the Little River Turnpike is in the foreground. The above-ground storage tanks are off to the left of Pickett Road, in the center of the photograph. Mantua subdivisions can be seen in the wooded patch at the right of the photograph. Shopping centers were later built on both northern sides of the intersection. (FCPLPA/Connection Newspapers.)

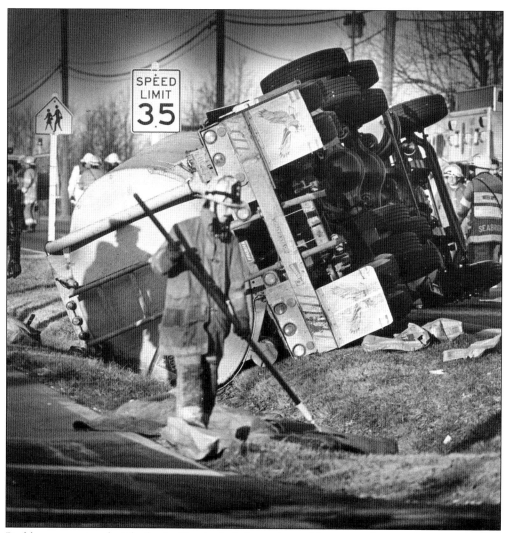

Problems associated with the facility included accidents. Here, a tanker truck overturned on the road. On June 24, 1977, a truck spilled fuel and ignited at the facility. The *Washington Star* reported on June 14, 1979, that a truck filled at the facility exploded on the Capital Beltway near Annandale, killing the driver and temporarily closing sections of that road and Route 236. Highway officials predicted backups of at least a month while road repairs were made. A decade before the underground oil plume that contaminated water and soil, the *Washington Post* reported on June 18, 1980, that the facility paid the City of Fairfax nearly $150,000 annually, plus $17,330 in personal property taxes and $500,000 in business license taxes. In May 1981, the Star Terminal reported that a 20,000-gallon gas overflow on its site necessitated the evacuation of 350 residents of nearby Comstock townhouses. In January 1982, the *Fairfax Journal* reported that state delegate John H. Rust introduced a bill to give city officials the right to inspect safety alarms on all tanks. (FCPLPA/Connection Newspapers.)

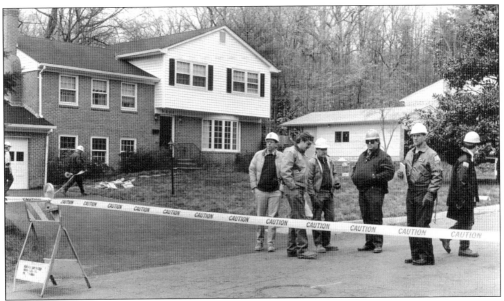

In September 1990, a Mantua resident reported an oily sheen in Accotink Creek's Crook Branch. The Virginia Department of Environmental Quality investigated the source: Texaco at the tank farm. In March 1991, Star Enterprise, the facility owner, began installing trenches to prevent further migration of petroleum. In April 1992, the first of four families were evacuated, including the second house on Convento Drive. Above, groups, including the Environmental Protection Agency, prepare to dig a well-monitoring system. Left, an environmental technician measures petroleum product and water level in a well. The *Washington Post* reported, "It's unclear how much underground oil began creeping toward homes 19 months ago. Estimates range from 100,000 gallons to as much as 4.5 million. Dozens of homes have been threatened as the oil has seeped close enough to basements to create fire and explosion hazards." (Both, FCPLPA/ Connection Newspapers.)

Above, Mantua resident Karen Williams talks with Virginia governor Douglas Wilder. In May 1991, the Mantua Citizens' Association Board "voted unanimously to call for the immediate closing of the tank farm, and the draining of the oil storage tanks and pipes pending a thorough investigation of the source of the hydrocarbon product, and that they not be reopened until, and unless, the problem has been satisfactorily resolved." Wilder created an advisory commission in July 1992 charged with assisting the community with longer-term implications from the spill. It issued its findings in a December 1993 report that recommended relocation of the tank farm. It noted storage capability of 72.9 million gallons of petroleum product, distributing one billion gallons annually, and that at least 20 spills had been reported in 27 years of operation. Below, Wilder and commission members tour the facility. (Both, FCPLPA/Connection Newspapers.)

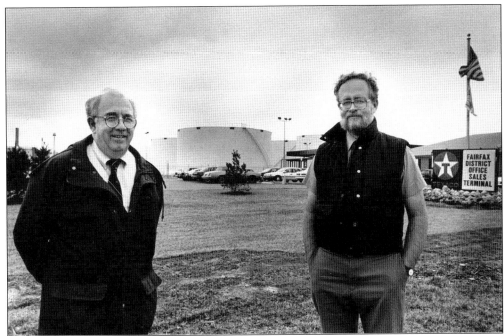

George Mason University professors George Mushrush (left), a biofuels expert, and Douglas G. Mose, an environmental chemistry and geology expert, studied the tank farm in 1992 and said the spill was larger than Texaco said. Petroleum products contained benzene, a carcinogen, alarming residents near the spill. (FCPLPA/Connection Newspapers.)

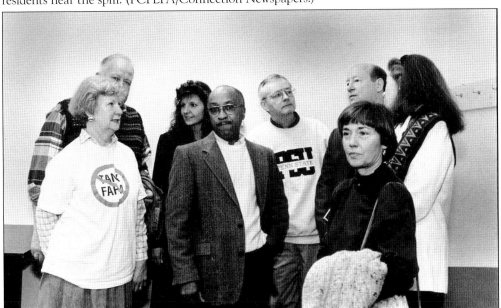

Members of Citizens for a Healthy Fairfax wait to meet with Governor Wilder. From left to right are Tyler Williams, Wanda Lewark, Charlie Turner, Walt Carlson, Frances Williams, David McIlwain, Kathleen Sheridan, and Kathleen McBride. By September 1993, a total of 53 of 65 Mantua houses evacuated by homeowners were rented to "caretakers," the *Fairfax Connection* reported, who paid $750 a month to Caretakers of America Inc. (FCPLPA/Connection Newspapers.)

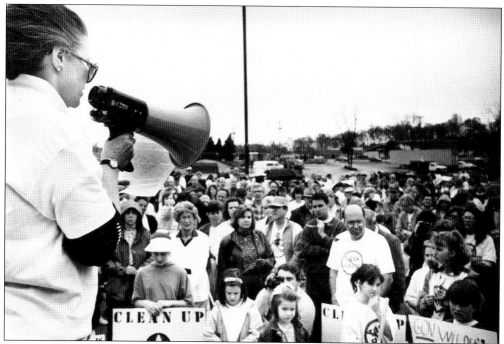

Kathleen Sheridan (above left), a spokesperson for Citizens for a Healthy Fairfax, a group formed to push for relocation of the tank farm, talks to people protesting across the street from the tank farm on Earth Day in April 1992. She told the *Washington Post*, "Until this hazardous tank farm is shut down and moved away from our neighborhoods, no one will be safe. The history of operations proves this. We call on the owners of the tank farm to act responsibly toward our citizens and the environment, and we demand that the facility be closed immediately." Citing more than 20 reported oil leaks and spills since the tank farm opened nearly 30 years ago, Sheridan showed a petition she said represented 2,488 households demanding that the tank farm close. Below, protestors wave to cars. (Both, FCPLPA/Connection Newspapers.)

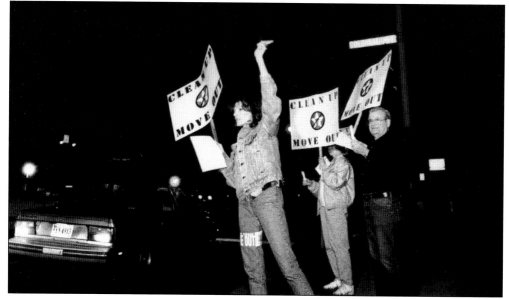

Kathleen Sheridan (above left), spokesperson for Citizens for a Healthy Fairfax, and Michael Hausfeld, attorney for homeowners who sued Star Enterprise, listen to Star's attorney at a City of Fairfax Board of Zoning Appeals hearing in October 1993. Below, citizens packed Fairfax City Hall. Hausfeld filed suit in Fairfax County Circuit Court in 1990, seeking $234 million for more than 110 homeowners. Star agreed in an out-of-court settlement to buy houses above the leak and compensate those affected by the spill. In exchange, those suits and about 70 other out-of-court claims were dropped. The settlement marked the first time a company reached a comprehensive settlement with a group of homeowners rather than with the EPA or other entity. The *Washington Post* reported that Texaco paid about $50 million to settle medical and other damage claims made by about 180 families. (Both, FCPLPA/Connection Newspapers.)

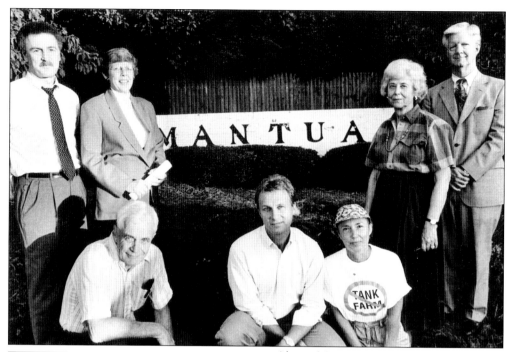

Above, Mantua Citizens' Association tank farm committee members were, from left to right, (first row) James Pickford, Steve DelBianco, and Kathleen McBride; (second row) Jack Maskell, Sally Ormsby, Fran Kieffer, and Paul Hammack. Star agreed to spend $2.5 million on improvements to fuel-storage tanks, including installing double bottoms on above-ground tanks and double-sealing tanks with floating roofs to reduce vapor emissions. In 2011, state senator Chap Petersen and Delegate David Bulova pushed for double-bottom tanks. Rep. Gerry Connolly, Fairfax County Providence District supervisor Linda Q. Smyth, and other elected officials endorsed the regulations. At Fair City Mall next to the tank farm, a permanent oil recovery system was installed. This stripper tower (left) tests water and will purify water tainted with petroleum product. Star Enterprise was obligated to clean up the spill, estimated in September 1992 at more than 100,000 gallons. (Both, FCPLPA/Connection Newspapers.)

In May 1993, Star Enterprise released a study done by Environmental Science & Engineering, Inc. with a map showing the extent of the underground plume and remediation systems for extracting petroleum product. Homeowners directly above the plume were offered prices ranging from about $320,000 to $360,000 for their houses. In 1992, about 300 homeowners in the secondary area outside the plume signed a 10-year "property value protection plan," guaranteeing that their house would be bought by Texaco Refining and Marketing, Inc. if they were unable to sell it within six months, in exchange for a release of claims against Star Enterprise, Texaco, and their affiliates. (Data Package Star Enterprise Terminal.)

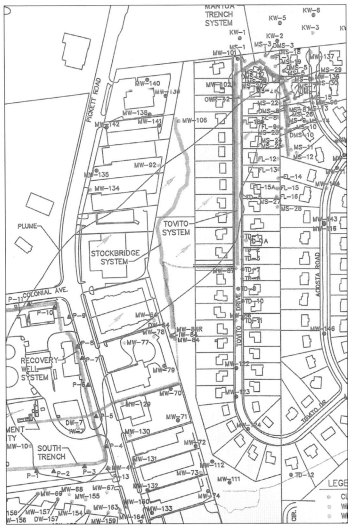

A trench system and monitoring wells (left) were located mainly along Tovito Drive, Convento Terrace, and Acosta Road. Wells also were placed on some streets outside the plume range. (FCPLPA/Connection Newspapers.)

After the 1990 spill, enforcement of tanker truck safety was mandated. Above, Virginia State Police inspect a truck before it leaves the tank farm. A soil and groundwater remediation system that began in 1991 was expanded and modified in 2000. It included vacuums to remove petroleum product from the soil. Monitoring wells collected petroleum-like substances in Mantua. In 1991, Star Enterprise offered a $500,000 payment to the Stockbridge Community Association (Tovito Drive) for the use of a common area for remediation. The EPA concluded that "it is necessary to restore groundwater to drinking water standards as a goal in order to protect human health and the environment." Below, firemen at the tank farm held drills and simulations of emergencies, including oil spills. (Both, FCPLPA/Connection Newspapers.)

Oil Panel: No Health Problems

Mantua, Stockbridge Safe But Some Questions Linger

By Matthew Brown
Times Staff Writer

An independent health report on the Star Enterprise petroleum tank farm in the City of Fairfax concludes there is no health threat left from the underground oil leak into nearby Mantua and Stockbridge in the early 1990s.

The Health Advisory Panel, made up of doctors with expertise in environmental hazards, found "no current or likely future public health threat from human exposure to ... the [petroleum] plume" released in the leak.

The report also recommended against any further health studies to monitor or assess health impacts.

Sally Ormsby, president of the Mantua Citizens possible questions in people's minds about the safety of living in the Mantua area," Ormsby said.

However, some residents maintain that the data used by the panel was incomplete and so could not provide a full accounting of the health hazards arising from the leak, an assertion confirmed by an Environmental Protection Agency team that has monitored the problem since it was first made public.

"The time that they were concerned with was the time before the control measures were put in place," said Betty-Ann Quinn, a toxicologist with the EPA. Quinn added that this data is irretrievable. "You can't manufacture data."

Mantua resident and Fairfax County Supervisor Gerald Connolly (D-

In 1993 Dr. James P. Lamberti, a Fairfax pulmonologist, linked the oil spill to a high incidence of asthma among 183 residents he examined, the *Fairfax Connection* reported. All were plaintiffs in a lawsuit against Star Enterprise. An expert on toxic risk hired by Star criticized the study, saying it lacked a control group and included preexisting cases. Lamberti acknowledged that his study was imperfect, but three area lung doctors defended it. In 1996, a Health Advisory Panel composed of doctors with expertise in environmental hazards concluded that the Star plume posed no health risks and recommended against further studies to monitor or assess health impacts. Mantua Citizens' Association president Sally Ormsby told the *Fairfax Times* on January 25, 1996, "It will put to rest any possible questions in people's minds about the safety of living in the Mantua area." (The *Fairfax Times*.)

As a result of the oil leak, as well as the 1990s recession, real estate values in Mantua plummeted. The *Fairfax Connection* reported in April 1995 that one Acosta Road house valued at $303,000 fell to $210,000 in one year. The stigma of the leak persisted. Texaco funded a community information center on Silver King Court in the Mantua Professional Center that abuts the neighborhood near one end of Glenbrook Road near Pickett Road. It promoted Mantua in advertisements in newspapers and magazines, touting amenities—good location, top schools, and close-by shopping. A new slogan was created: "Mantua: A Real Neighborhood Experience." A logo (above) incorporating the trees that define the natural environment was trademarked. Texaco created a Community Enhancement Program of $600,000 that the Mantua Citizens' Association used for new signs such as the one above, landscaping, park trails, and a technology program at Mantua Elementary School. The EPA continues to monitor the tank farm site, but after determining that remediation was no longer needed, the last wells in the neighborhood were shut down in 2019. (Photograph by the author.)

Seven

CHANGES AND CONNECTIONS

In the early 20th century, widespread use of the automobile changed the way people live. Whether for business travel or vacation, Fairfax Circle attracted people passing through. It was close to roads that had been in use since the previous century, a well-worn path to Falls Church.

In the 1930s, shops and services appeared near the confluence of Routes 29, 211, and 50 to cater to these travelers. After World War II, it became common for American middle-class families to take vacations—to take a road trip. In response, independently owned hotels, motels, and eateries were born in places like Fairfax Circle.

And as Fairfax County developed and suburbs like Mantua grew in the 1960s, shopping centers also were built there and at the Little River Turnpike and Pickett Road intersection to serve residents as well as travelers. Since then, many retail stores and shops have come and gone, affected by recessions and economics and even more development.

Property lines between the City of Fairfax and Fairfax County were and are sometimes indistinct, but many Mantua residents consider it their city, a convenient place for shopping, dining, and recreational activities. Before and during the Civil War, Fairfax Court House was a magnet for citizens. The county courthouse complex on 48 acres in the city center (which is part of Providence District) remains so today.

The distinction between city and county has been a challenge for decades. One house in the Mantua Hills subdivision on Glenbrook Road and part of the private Mantua Swim and Tennis Club has land in both jurisdictions. Pickett's Reserve, a subdivision adjacent to Mantua that shares parkland in between, is in the city but once was in the county. Change happens, and new connections are forged. This chapter is a look at some of the changes and connections as the suburb grew.

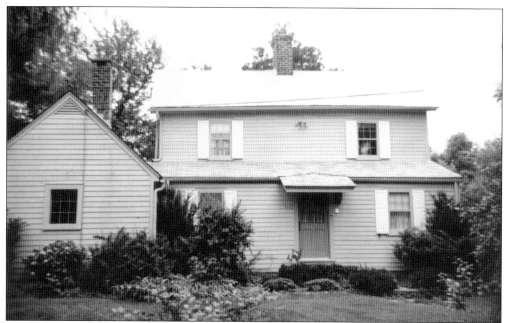

The six-room farmhouse at 3445 Pickett Road, above, was the residence of scientist and businessman Shelley Krasnow. In 1958, the City of Fairfax annexed a third of his 39-acre tract, which also contained a barn, below. He said the city violated the conditions of annexation, which stipulated it devise a master plan for development that treated the area and town equally "by agreeing to the construction of a tank farm (gasoline depository) and to other industrial development." Krasnow wanted to preserve his house, 180 years old in 1977, built with hand-hewn beams fitted together with wooden pegs. The city wanted to widen Pickett Road. In 1989, Krasnow bequeathed his property to George Mason University for a research institute. The university sold it and built the Krasnow Institute for Advanced Study on its main campus. The house was demolished. (Both, FCPLPA.)

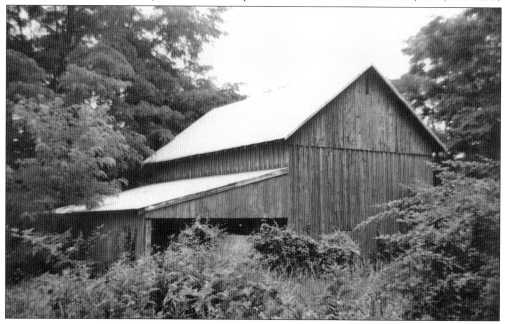

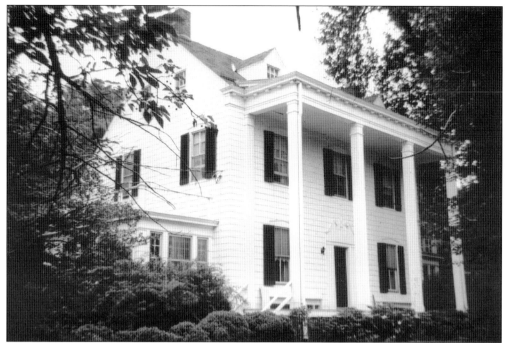

This privately owned house built around 1850 still exists on John Gladdin's 300-acre, 1742 land grant from Thomas, sixth Lord Fairfax. The Pickett's Reserve development surrounds it. In the early 20th century, Pickett Road was known as Schuerman Lane after German immigrant and landowner Charles W. Schuerman. The name changed to Pickett in the 1950s. The road cut through the land grant from Lee Highway to Little River Turnpike. (FCPLPA.)

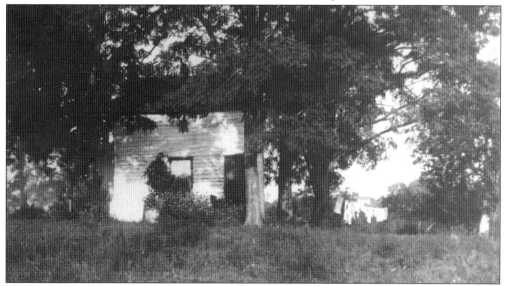

In the 1930s, this log cabin burned on the Swayze farm, located near Pickett Road and Fairfax Circle. The land today is part of the members-only Army-Navy Country Club, 3315 Old Lee Highway, which bought it in 1946. The first 10-hole course was designed by the noted Robert Trent Jones Sr. The club has 27 holes on about 232.46 acres valued at $33 million, according to city property records. (FCPLPA.)

The Fairfax Circle area has changed a great deal. The intersection of major roads—Routes 29 and 211 and 50—spurred development in the 1930s, 1940s, and 1950s. Most were independently owned tourist hotels, motels, and cabins, gas stations, and eating places. Ades Camp Comfort, shown here, was, according to its postcard advertisement, "a home away from home. Modern cottages and lunch room. Trailway bus stop." Its phone number was Crescent 318-W. It had a service (gas and auto repair) station. There was competition; the Boulevard Motel (reservations by telephone at Crescent 865) offered "hot water heat. Cross ventilation. Tile baths, tubs and showers. Mr. and Mrs. Hanna Hadeed, owners and operators." (Both, FCPLPA.)

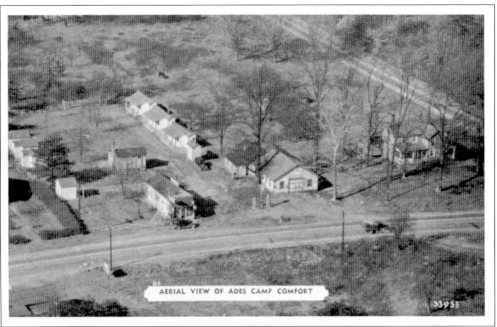

AERIAL VIEW OF ADES CAMP COMFORT

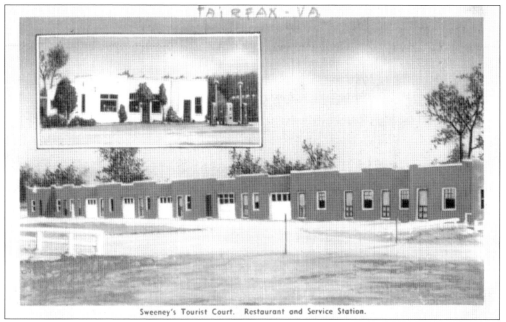

Sweeney's Tourist Court. Restaurant and Service Station.

Sweeney's Tourist Court was located near Fairfax Circle in the 1940s. Its postcard advertisement, above, lured travelers by emphasizing that it was only 12 miles from Washington, DC. It also had amenities all in one place: "modern steam heated cabins, service station and restaurant" in this long, low one-story structure. The Coffee Shoppe on Lee Highway was in a small white frame building as early as the 1930s. (FCPLPA.)

Tourist amenities stretched through the City of Fairfax to Kamp Washington. The Capital Courts Motel, shown here in 1980, offered these private, compact cabins on Routes 29 and 211. Picnic tables encouraged al fresco dining. There also were trailers on-site for rent. Most of the hotels and tourist places were independently owned, not affiliated with chains. (FCPLPA.)

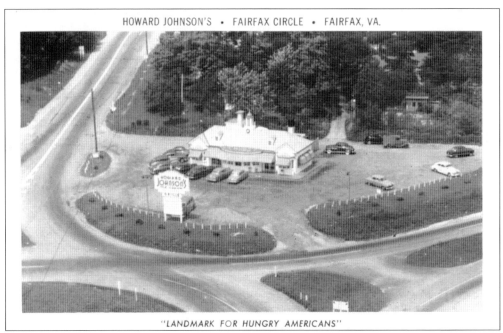

"LANDMARK FOR HUNGRY AMERICANS"

Howard Johnson's was an exception at Fairfax Circle: a chain motel. Postcards declared it was the "Landmark for Hungry Americans." The chain itself was bought by Wyndham, but the Fairfax Circle location eventually succumbed to development. Mid-century places nearby that survive include the Anchorage Motel, which was built like a ship bow. (FCPLPA.)

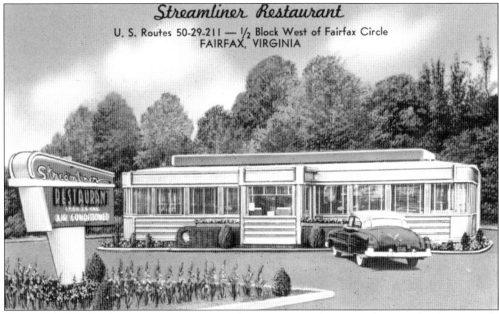

In 1940 the Streamliner Restaurant was a place at Routes 50, 29, and 211 with "distinctively different food." It was open 24 hours, air-conditioned, and owned and operated by Robert J. and Esther Parcelles. Its competition included Lee's Diner, which specialized in home-cooked meals, seafood, steaks, and chops. Lee's was owned and operated by Ben B. and Dorothy Simpson and, later, Mickey and Lee Gray. (FCPLPA.)

On Mantua's northern border was Fairhill Farm, part of the 220 acres owned in 1860 by Jane E. Chichester, the widow of William H. Chichester, brother of George Chichester. Her land included the portion of Chichester Lane across Arlington Boulevard. It was between Cedar Lane to the west, Prosperity Avenue to the east, Lee Highway to the north, and Arlington Boulevard to the south. In 1860, Jane owned 12 enslaved persons. She listed about 160 acres being used for cattle, milk cows, horses, sheep, and hogs and growing corn, oats, and potatoes. Fairhill Farm's address was 8731 Lee Highway in 1969. The photograph above shows the north side of the farmhouse. Below, an old plow lies in a field not far from wagon wheels. (Both, FCPLPA.)

As development for housing encroached on all sides, later owners of the Fairhill farm tried to make their living by turning the place into an entertainment venue. An old wagon (above) advertised the Melody Memories Museum, which was set up in the old barn (below). A sign in front advertises "band organs, calliopes [a keyboard instrument that resembles an organ but uses a steam whistle to sound notes], and nickelodeon piano players [similar to a jukebox, where one inserts a coin]." The farm had a history of economic troubles; in 1841, William H. Chichester was in debt and had tried to sell his land at public auction. "The farm is considered one of the most productive and valuable in the County," the newspaper notice said. He also tried to sell "about twenty young and valuable slaves." (Both, FCPLPA.)

Until the mid-20th century, Fairfax County schools were segregated. In 1954 the Supreme Court ruled in *Brown v. Board of Education* that segregation was unconstitutional. However, Fairfax County did not desegregate until 1960, after Virginia's Fourth Circuit Court of Appeals ordered the schools to integrate. Full integration was not achieved until 1971. That year, Mantua students were bused to Luther Porter Jackson Intermediate School on Gallows Road in Merrifield (Falls Church). From 1959 to 1964, Luther Jackson had been a high school for Black students. This photograph shows English teacher Mrs. ? Whittaker (left) and Helen Scarr, who lived on Saint Paul's Place, in the classroom. Mantua students later attended Frost Middle School at 4101 Pickett Road. Woodson High School is adjacent. Woodson was built on a dairy farm that operated until 1959. Mantua students also attend the selective Thomas Jefferson High School for Science and Technology in Alexandria. Mantua Elementary is the only school within the suburb. (Cindy Buchanan.)

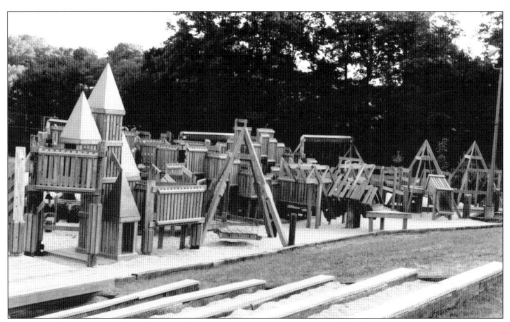

Mantua Elementary School opened in 1961. A new section was added in 1969 with a gymnasium, music room, science room, and three "pod" areas. By 1980, an average of 416 students from 314 families attended kindergarten through grade six. Pictured here in the early 1980s, a custom-designed playground by Robert Leathers was installed at the back of the school. It had old-tire swings, obstacle paths, and swinging platforms. (Gene R. Shuman.)

Students at Mantua Elementary constructed and decorated a Victorian dollhouse as part of a lesson in the early 1990s. They furnished its rooms with fabrics similar to the period. In 2020, a total of 1,975 students were enrolled at Mantua, according to Fairfax County Public Schools. The addition of trailer-like classrooms had become permanent on the campus. (FCPLPA.)

In 1978, the Mantua student body selected a raccoon as the school mascot "because it is indigenous to the area and can be found in abundance around the school," according to J. Regenia Dalton, principal in 1980. The school later adopted the motto "Home of the Raccoons." To celebrate the elementary school's 25th anniversary in 1986, the Parent-Teacher Association volunteers compiled the Mantua Dessert Book, whose cover is shown here. It reflected the times: more women were working outside the home. There was Charlie Cossairt's Working Woman's 10-Minute Chocolate-Cheese Pie; Pat Morris's Dump Cake (below), in which one shoves the ingredients in a pan, mixes them, and bakes; and Judy Wonus's Quick Nut Fudge. A young cook's section contained a recipe for chocolate chip cookies that calls for 112 pounds of chips and makes 10,000 cookies. (Both, author's collection.)

```
DUMP CAKE                                    Pat Morris

1 can (1 lb. 6 oz.) Cherry Pie Filling
1 can (8 1/4 oz.) crushed pineapple,
    undrained
1 pkg. yellow cake mix
2 sticks margarine, melted
1 can (3 1/2 oz.) flaked coconut
1 c. chopped pecans

Dump cherry pie filling evenly in bottom of a
9 x 13 inch pan.  Spread pineapple over cherry
mixture.  Sprinkle dry cake mix evenly over all.
Pour melted margarine over cake mix.  Top with
coconut and pecans.  Bake at 325° for 1 hour.
Cool before serving.  Top with ice cream or
whipped cream, if desired.
```

Several religious congregations are located on Little River Turnpike in Mantua, besides Chabad Lubavitch of Northern Virginia (see page 62). The Church of God Prophecy, 8950 Little River Turnpike, occupies a 2,027-square-feet building on 1.984 acres in the Sunny Hill subdivision. Built in 1959, it was sold by Seventh-day Adventists Potomac for $1.7 million in 2016. Bethlehem Lutheran Church, on 3.6 acres, at 8922 Little River Turnpike, celebrated 50 years in 2012. The largest in footprint is the Pozez Jewish Community Center of Northern Virginia, located on 6.21 acres on the turnpike at Guinea Road. Above, Rabbi Itzhaq Klirs of Congregation Olam Tikvah holds the shovel at the 1988 ground-breaking ceremony. To his left is Rep. Leslie Byrne, and to her left is Jeffrey Karatz, executive director of the Jewish Community Center of Northern Virginia. The center started in a house that was transformed into the Smith-Kogod Cultural Arts Center in 2019. A wide range of other activities is available for members and non-members. There is also a preschool. (Pozez Jewish Community Center of Northern Virginia Archives.)

Congregation Olam Tikvah's Synagogue was started on Glenbrook Road, east of the Little River Turnpike at 3834 Glenbrook Road, and grew with the suburb. This article in the *Jewish Week* newspaper reported on the dedication and consecration ceremony in 1966. County property records show that a house built in 1955 on about half an acre was bought for $22,500 in 1967. That building was used for services and as a residence until about 2010. Other parcels of land in that area were added to gradually make almost seven acres. In September 1969, a ground-breaking ceremony was held to begin the synagogue, shown below. (Right, Olam Tikvah; below, photograph by the author.)

THE JEWISH WEE

National Jewish Ledger

November 24, 1966 Washington, D.C. 11 Kislev 5727

A congregation dedicates its Torahs

A tradition continued

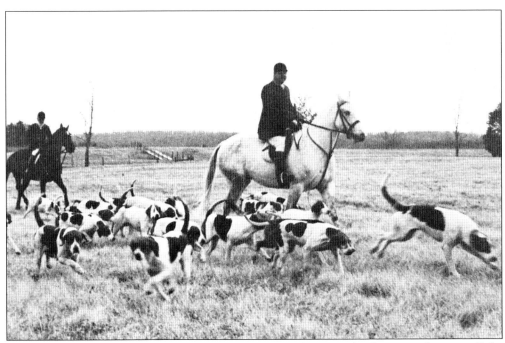

Members of the Fairfax Hunt Club once roamed the fields in search of game in the area off the Little River Turnpike that today encompass Mantua subdivisions. This photograph from the 1930s or 1940s shows open fields. To service the developing area, including the Mantua suburb, the Annandale Volunteer Fire Station sent this invitation to local groups when it expanded in November 1970 to a second location: Station 23, 8914 Little River Turnpike near Guinea Road. Station 8 is on Columbia Pike in Annandale. It is the only volunteer fire department with multiple stations in the county. Both provide emergency medical care and fire suppression for a wide area: the city of Fairfax in the west to Alexandria in the east, and Burke in the south to Merrifield and Bailey's Crossroads in the north. (Above, FCPLPA; below, Deputy Chief Gary Moore and the Annandale Volunteer Fire Department)

The Members of

The Annandale Volunteer Fire Department Inc.

cordially invite you to attend the

Dedication Ceremony of their new substation

at 2:00 p.m. on Saturday November 14, 1970

8914 Little River Turnpike, Fairfax, Virginia

The Roy Rogers eatery near Mantua (above)—now Einstein Bagel—made the *Boca Raton News* on September 4, 1977, when the chain founder visited: "Roy Rogers, 'King of the Cowboys,' was hit in the face with a pie while entertaining at the opening of another in his chain of family restaurants. Fairfax, Va., policemen at the Pickett Shopping Center quickly caught a 17-year-old boy who threw the pie-like concoction in the entertainer's face. Rogers, 66, was momentarily taken aback and said, "Let me get a poke at him. I hope they stuff a Roy Rogers hamburger down his throat." Right, Courtnie Prophett and her son, Joshua, visit the restaurant. Pickett Shopping Center was started in 1962. Turnpike Theater opened in the shopping center across Pickett Road in 1968. Its first movie was Steve McQueen in the action thriller *Bullitt*. (Both, FCPLPA/Connection Newspapers.)

As Mantua grew, more shopping and service opportunities appeared. Above, Spa Lady fitness counselor Karen Leffler works with member Sue Vengrin on the new equipment at the Fair City Mall, which opened in 1972. It also welcomed Marshalls, a one-stop place to purchase clothing, housewares, and gifts at a discount. Below, area manager Anita Whorton puts finishing touches on the merchandise before the grand opening. Mid-1970s stores in the Pickett area include a Miller and Wrenn furniture outlet (in the space Total Wine occupies), a discount drugstore called Bud's, and shoe "warehouses." The roofs were ripped off some of the Turnpike and Pickett shopping center stores when a tornado blasted through Fairfax in April 1973. More than 30 people were injured there and in nearby apartments, the *Washington Post* reported. Woodson High School also was damaged. (Both, FCPLPA/Connection Newspapers.)

BIBLIOGRAPHY

Abbott, Richard H. *Yankee Farmers in Northern Virginia, 1840–1860.* Richmond, VA: Virginia Historical Society, 1968.

Ames, David L., and Linda Flint McClelland. *Historic Residential Suburbs: Guidelines for Evaluation and Documentation for the National Register of Historic Places.* Washington, DC: US Department of the Interior, National Park Service, National Register of Historic Places, 2002.

ATR Associates, Inc. *Report for the MCA, Initial Review of Remedial Technology Pilot Studies at the Star Enterprise Site.* Fairfax, VA: May 8, 1996.

Carroll, Susan, and Iris Karl. *Mantua Dessert Book.* Fairfax, VA: Mantua Elementary School PTA, 1980.

Farrar, Emmie Ferguson and Hines, Emilee. *Old Virginia Houses of the Northern Peninsulas.* New York: Hastings House Publishers, 1992.

Harrison, Noel Garraux. *City of Canvas: Camp Russell A. Alger and the Spanish-American War.* Falls Church, VA: Falls Church Historical Commission, 1988.

Howard, Hugh. *How Old Is This House? A Skeleton Key to Dating and Identifying Three Centuries of American Houses.* the Noonday Press, Farrar, Straus and Giroux, 1989.

Johnson, Michael F. *American Indian Life in Fairfax County, 10,000 B.C. to A.D. 1650.* Falls Church, VA: Heritage Resources Branch, Office of Comprehensive Planning, Fairfax County, Virginia, 1996.

Janney, Samuel M. "The Yankees in Fairfax County, Virginia," republished from the *Richmond (VA) Whig.* The Cornell University Library Digital Collections, p. 184.

Johnson, William Page. *Brothers and Cousins: Confederate Soldiers and Sailors of Fairfax County.* Athens, GA: Iberian Publishing Company, 1995.

Mackall, Henry C. John Henry Chichester of Mantua, Historical Society of Fairfax County, Virginia. Yearbook, Vol. 30, 2005–2006, pp. 64–93.

Mitchell, Beth. *Beginning at a White Oak . . . Patents and Northern Neck Grants of Fairfax County.* Virginia. Fairfax, VA: Fairfax County Administrative Services, 1977.

Mitchell, Beth, and Sweig, Donald, ed. *Fairfax County, Virginia, in 1760: An Interpretive Historical Map.* Fairfax County, VA: Office of Comprehensive Planning, 1987.

Netherton, Nan. Fairfax. *Virginia: A City Traveling through Time.* Fairfax, VA: History of the City of Fairfax Round Table, 1997.

Stephenson, Richard W., and Marianne M. McKee, eds. *Virginia in Maps: Four Centuries of Settlement, Growth, and Development.* Richmond, VA: Library of Virginia, 2000.

Wayland, John Walter. *Historic Homes of Northern Virginia and the Eastern Panhandle of West Virginia.* Staunton, VA: McClure, 1937.

DISCOVER THOUSANDS OF LOCAL HISTORY BOOKS FEATURING MILLIONS OF VINTAGE IMAGES

Arcadia Publishing, the leading local history publisher in the United States, is committed to making history accessible and meaningful through publishing books that celebrate and preserve the heritage of America's people and places.

Find more books like this at
www.arcadiapublishing.com

Search for your hometown history, your old stomping grounds, and even your favorite sports team.